STEAMPUNK SOURCEBOOK

Prof. M.C. Waldrep

Dover Publications, Inc.
Mineola, New York

Bibliographical Note

Steampunk Sourcebook is a new work, first published by Dover Publications, Inc., in 2011.

DOVER *Pictorial Archive* SERIES

International Standard Book Number

ISBN-13: 978-0-486-48111-1
ISBN-10: 0-486-48111-5

Manufactured in the United States by Courier Corporation
48111502
www.doverpublications.com

Introduction

Steampunk: a genre of science fiction that typically features steam-powered machinery rather than advanced tecnology.
 Oxford World Dictionary

Steampunk is a subgenre of speculative fiction, usually set in an anachronistic Victorian or quasi-Victorian alternate history setting.
 Urban Dictionary (www.urbandictionary.com)

Essentially, steampunk is a fictional story set in, or evocative of, the 19th century, often in but not limited to Victorian England, and including real world devices created ahead of their time and/or imaginary devices based on prevailing theories of the era and/or prevalent ideas of the supernatural.
 Airship Ambassador (www.airshipambassador.com)

So, just what exactly is steampunk? The definitions above give us a start, but as you will learn, steampunk is much, much more. For some of us, it is a way of life.

The term, with its tongue-in-cheek nod to cyberpunk, was coined in the late 1980s by author K.W. Jeter to characterize his works, as well as those by Tim Powers and James Blaycock, works now considered seminal to the genre.

While steampunk literature is growing in popularity, invading the mystery and romance genres as well as science fiction and fantasy, the term has far outgrown its literary beginnings. Steampunk has become a cultural phenomenon. Films, such as the recent *Sherlock Holmes* and *Cowboys & Aliens*, have steampunk elements; online blogs and magazines devoted to steampunk abound; steampunk enthusiasts gather at conventions dressed in steampunk style; bands bill their music as steampunk, and steampunk artists create such diverse objects as vehicles, computers, jewelry, and fashion, as well as paintings and illustration.

This volume contains your passport to steampunk style. More than 500 images, from damsels in distress to clockworks to infernal machines are offered here. To demonstrate the versatility of the images, I called upon my talented colleagues at Dover. Madame Marie Zaczkiewicz has created some striking black and white collages for the interior of the book, and Commodore Jeff Menges designed a fabulous cover. Wanting still more, I prevailed upon Professor Chris Spollen (his title is real, unlike mine) of the Fashion Institute of Technology to challenge his students to submit works in color to our Steampunk Sourcebook contest. As judged by the knowledgeable staff at Dover, the three prizewinners, as well as twenty honorable mentions are shown in the book.

On the CD, you will find all of the images as well as the collages by Madame Marie and the students. All files are offered as both high-resolution and Internet-ready JPEGs. The "Images" folder on the CD contains four different folders. All of the high-resolution image files are in one folder, and the Internet ready image

files are in another. Every image has a unique file name in the following format: xxx.jpg. The first 3 digits of the file name, before the period, correspond to the number printed under the image in the book; the last 3 letters, "JPG," refer to the file format. So, 001.jpg would be the first file in the folder. The collages can be found in the "Winners High Resolution JPG" and Winners JPG" folders. These files are identified by page number.

Also included on the CD-ROM is Dover Design Manager, a simple graphics editing program for Windows that will allow you to view, print, crop, and rotate the images.

For technical support, contact:
Telephone: 1(617) 249-0245
Fax: 1(617) 249-0245
Email: dover@artimaging.com
Internet: http://www.dovertechsupport.com

The fastest way to receive technical support is via email or the Internet.

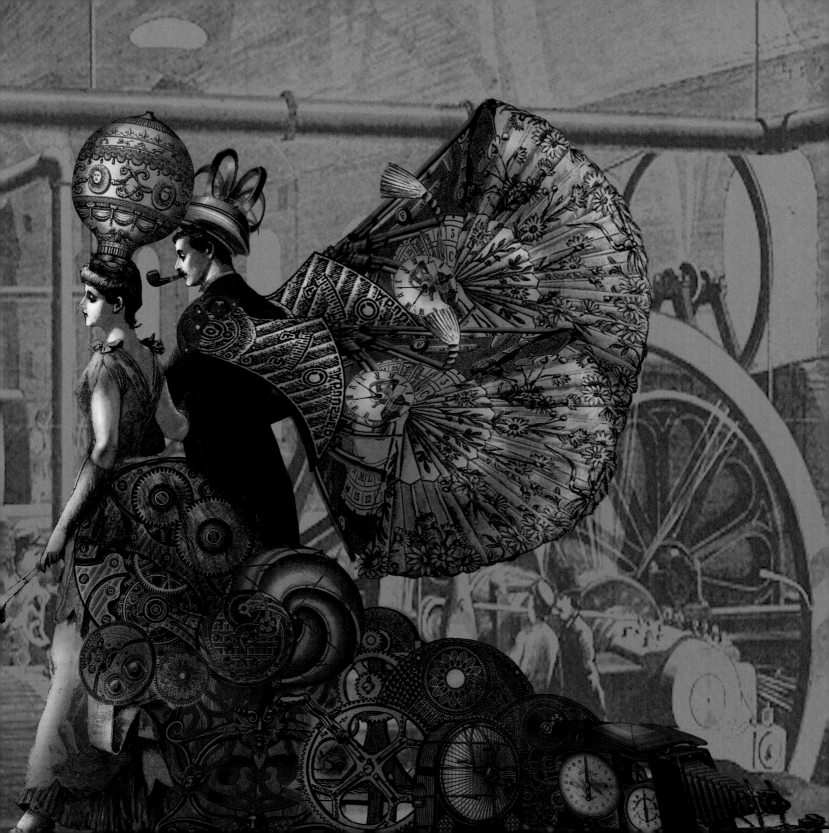

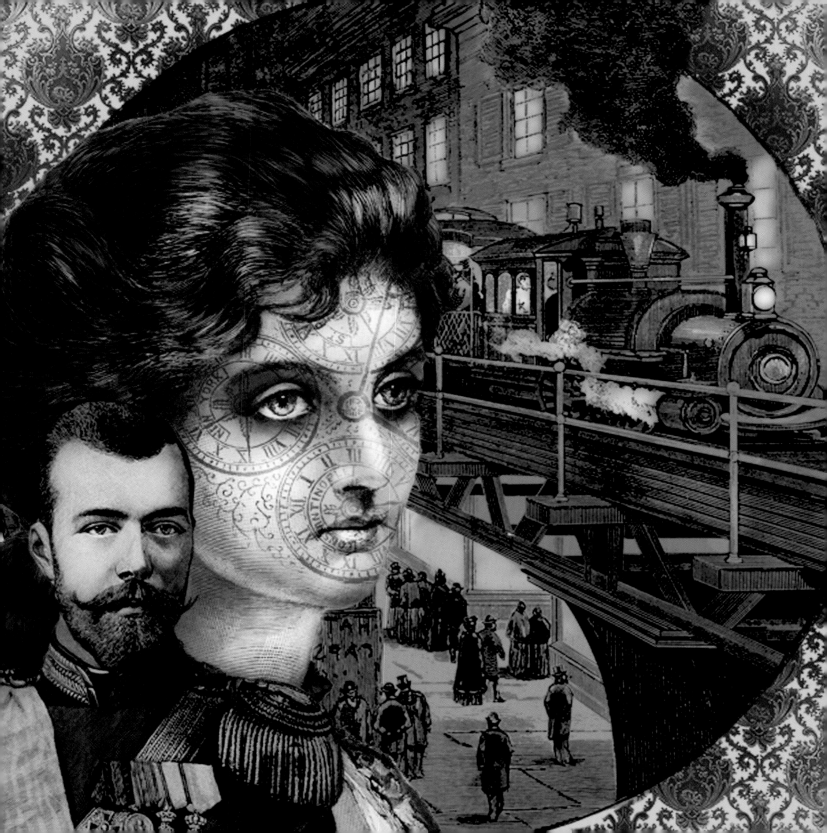

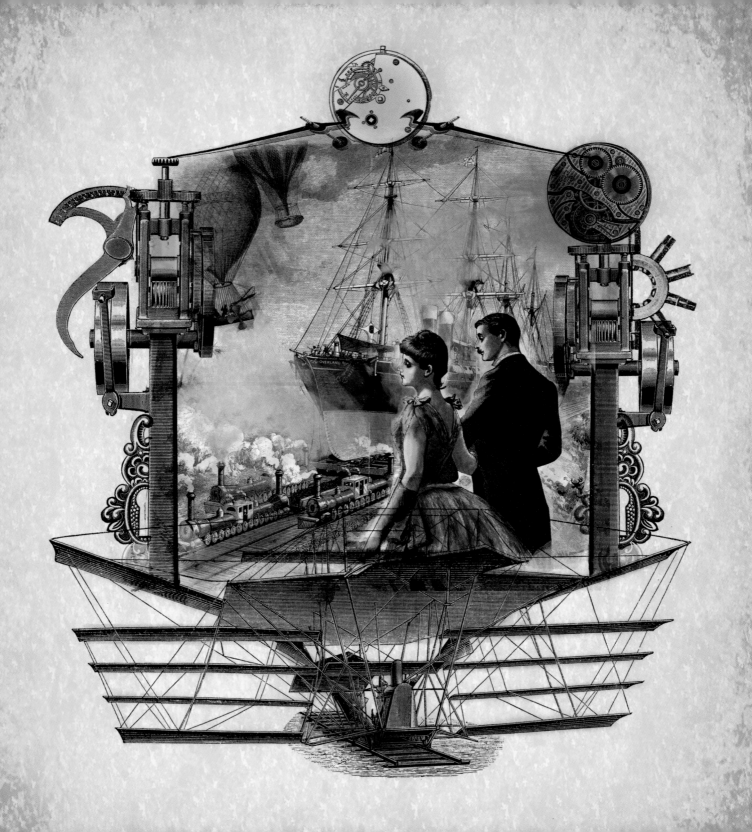

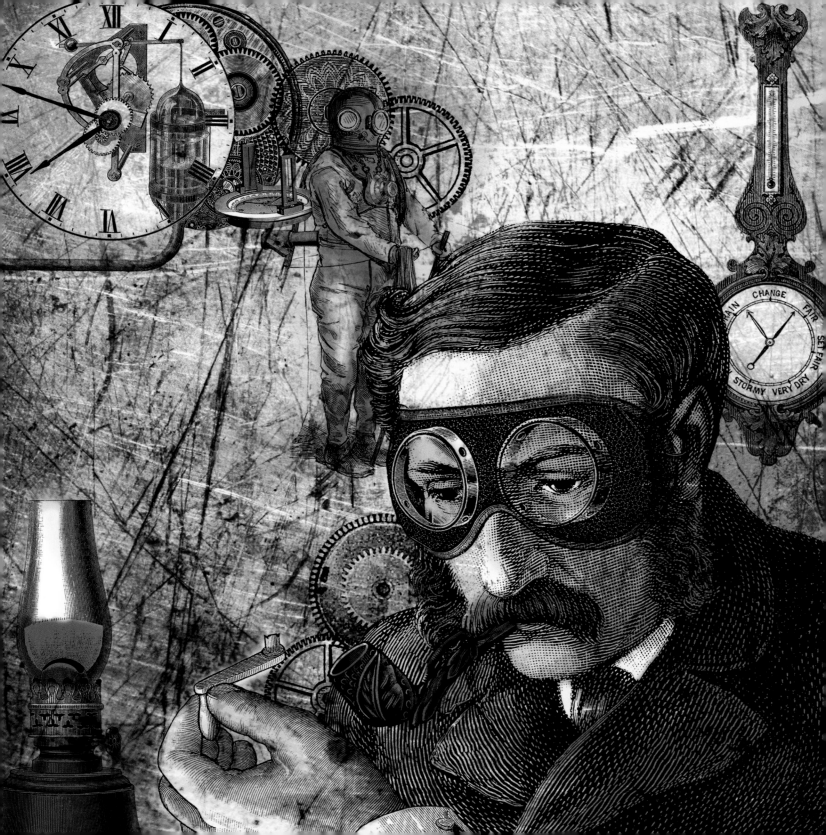

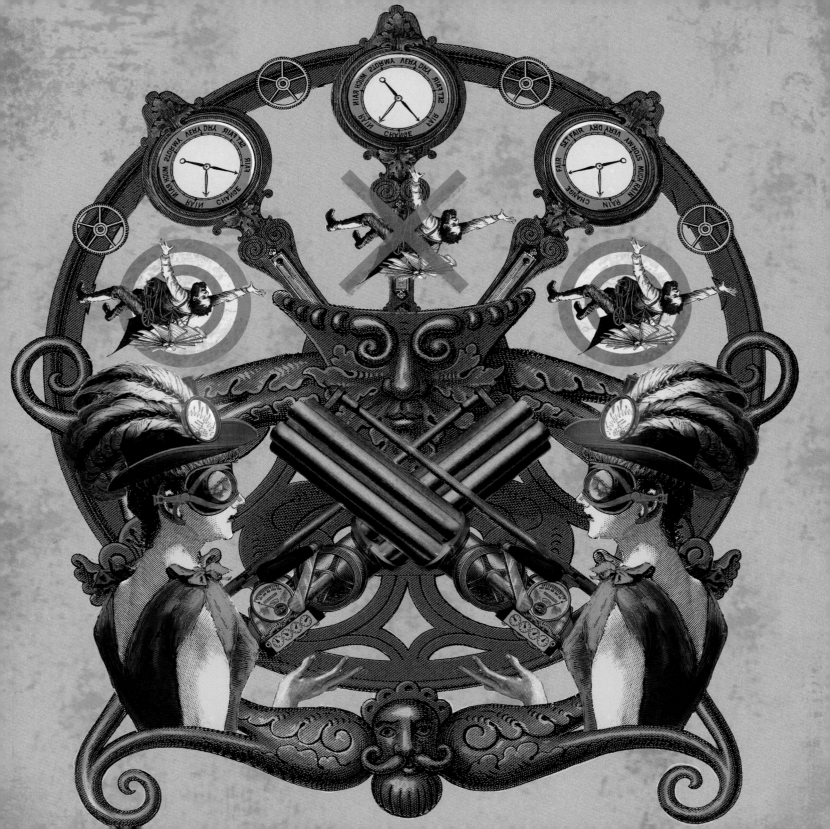

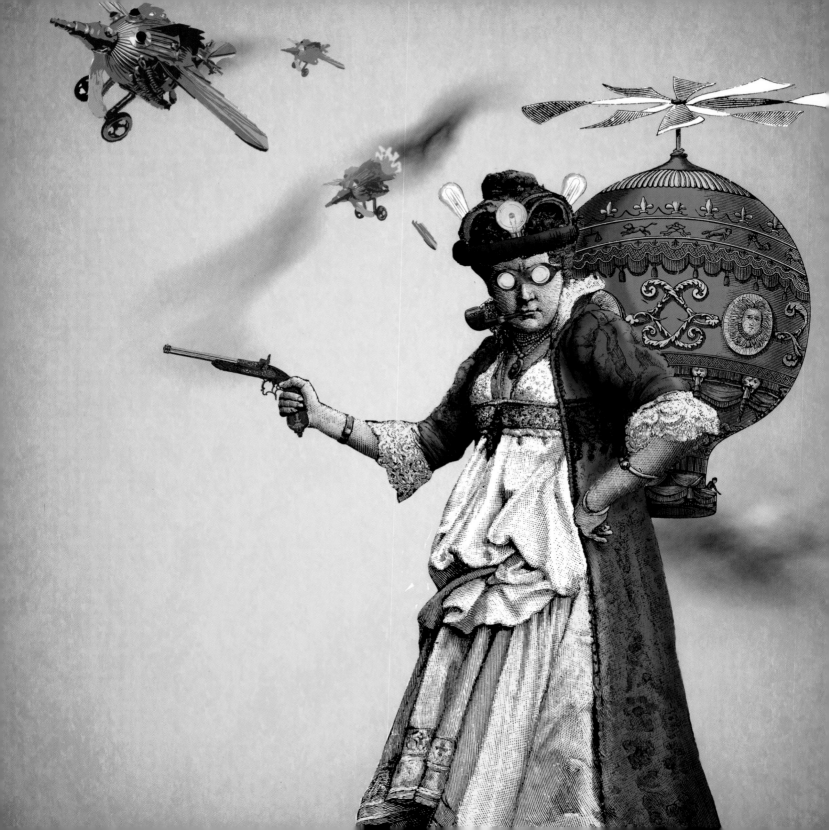

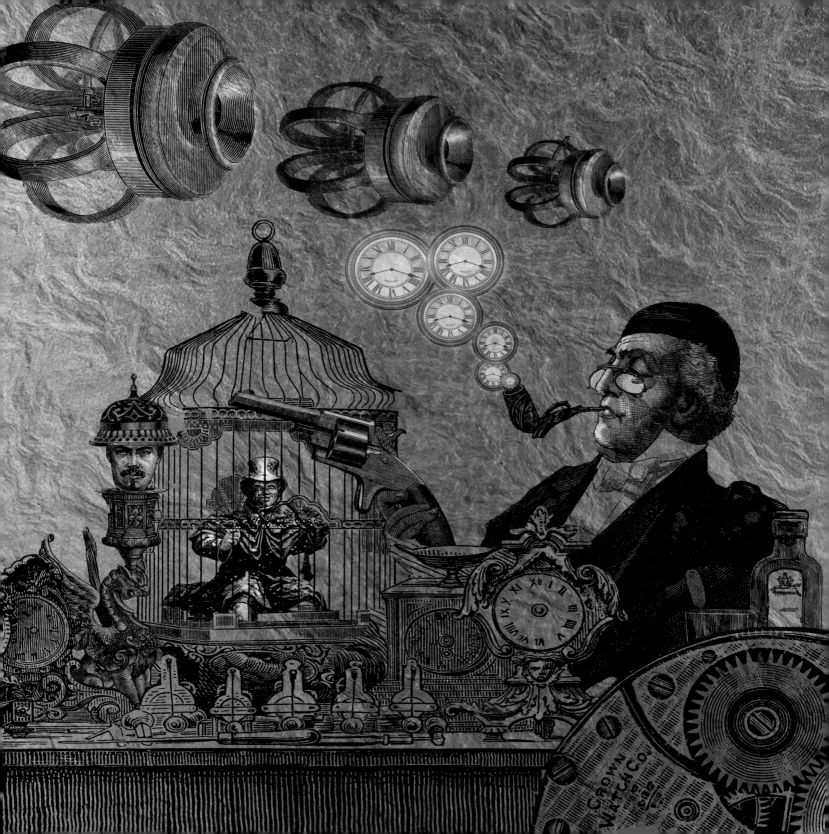

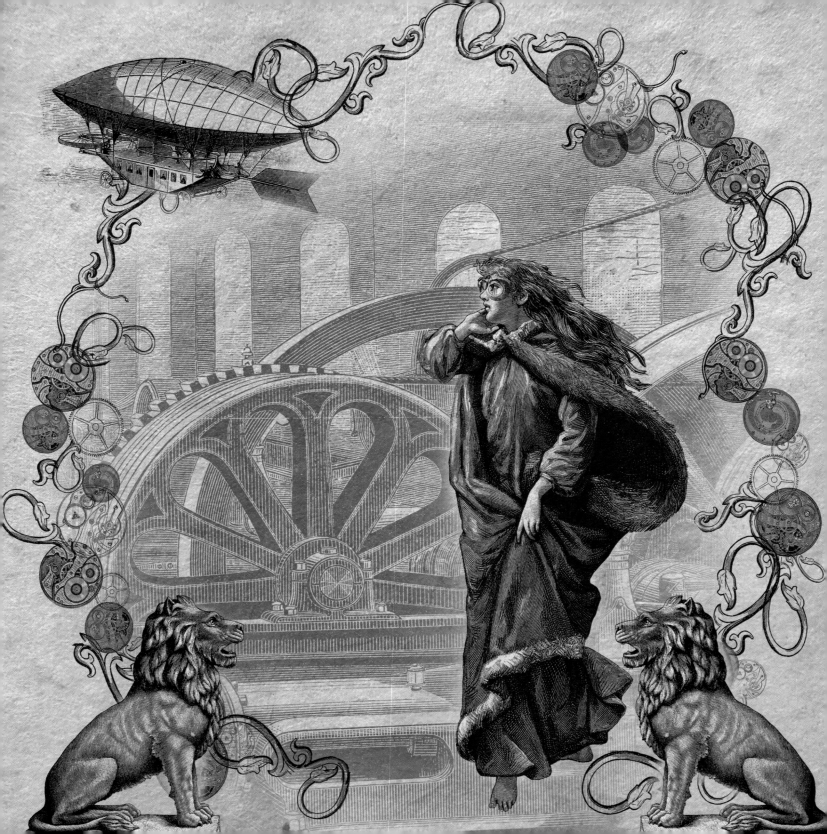

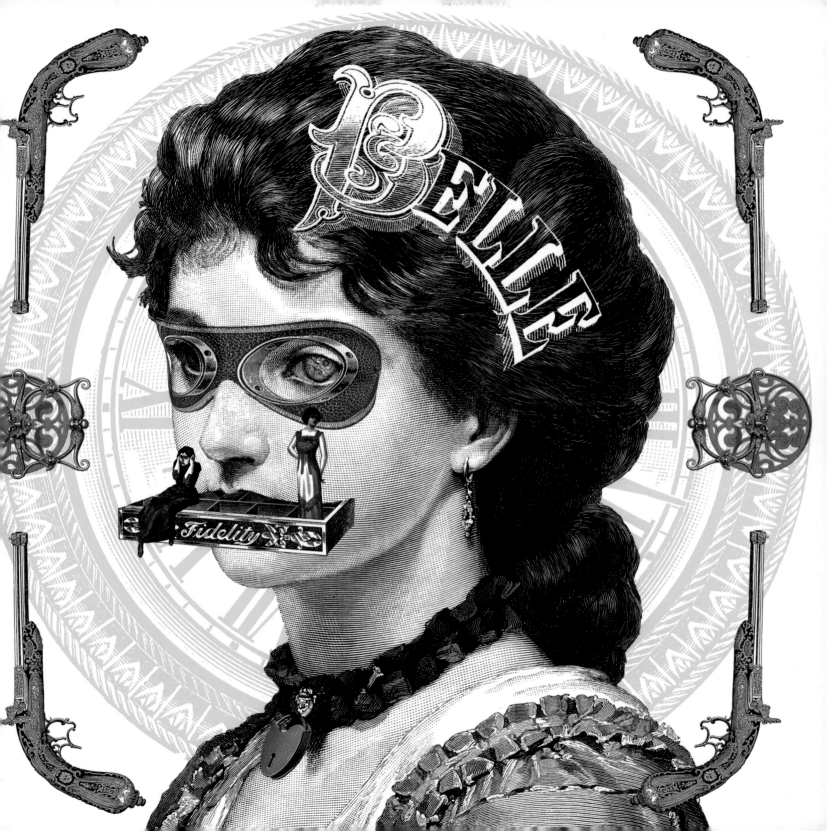

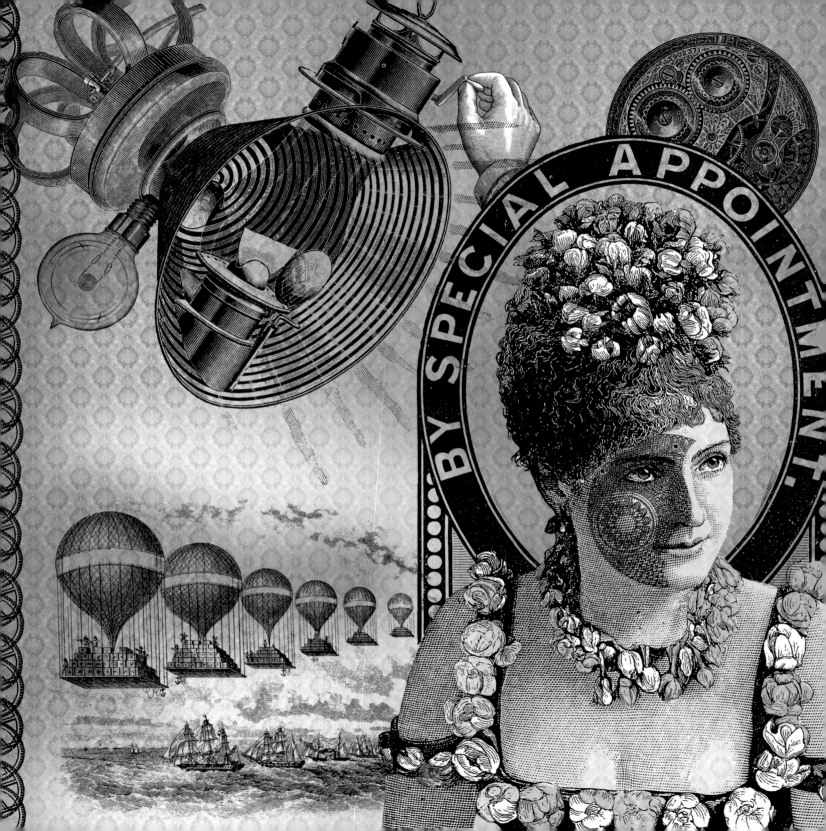

BY SPECIAL APPOINTMENT.

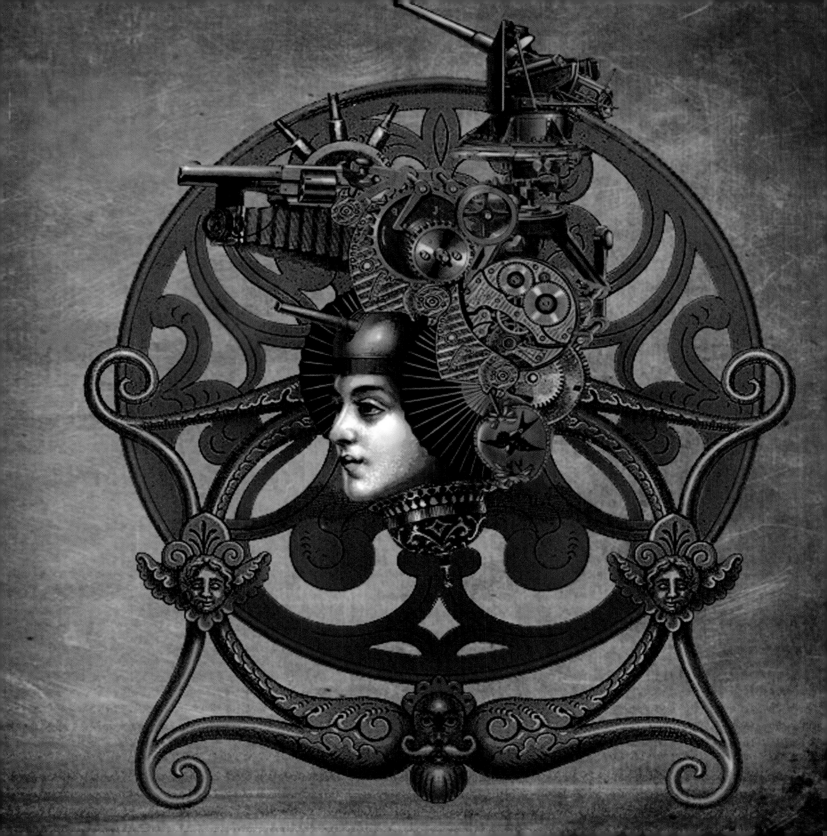

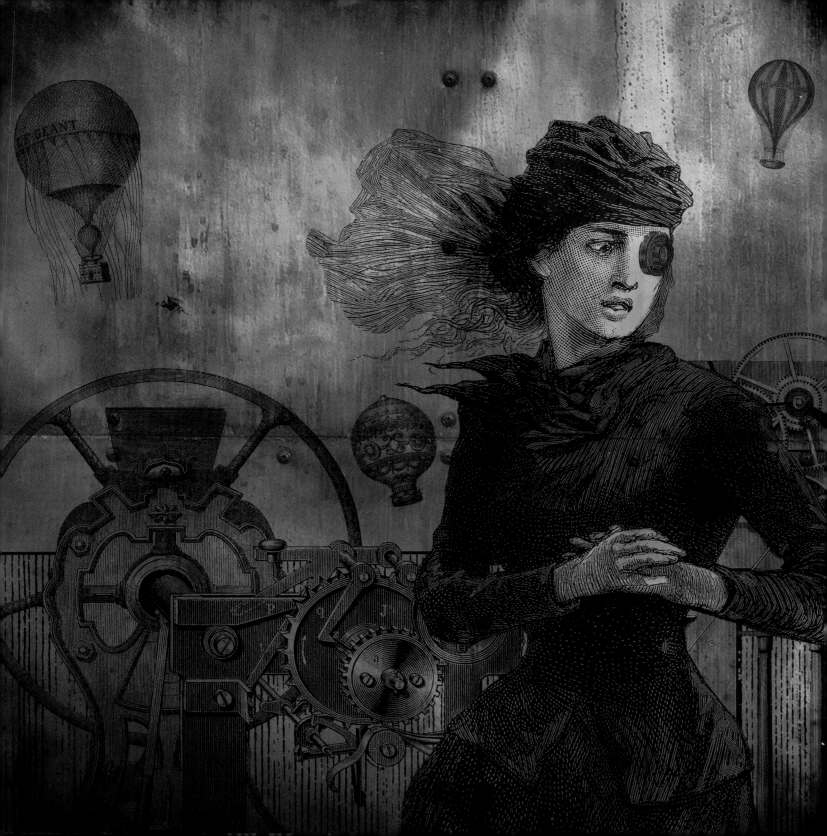

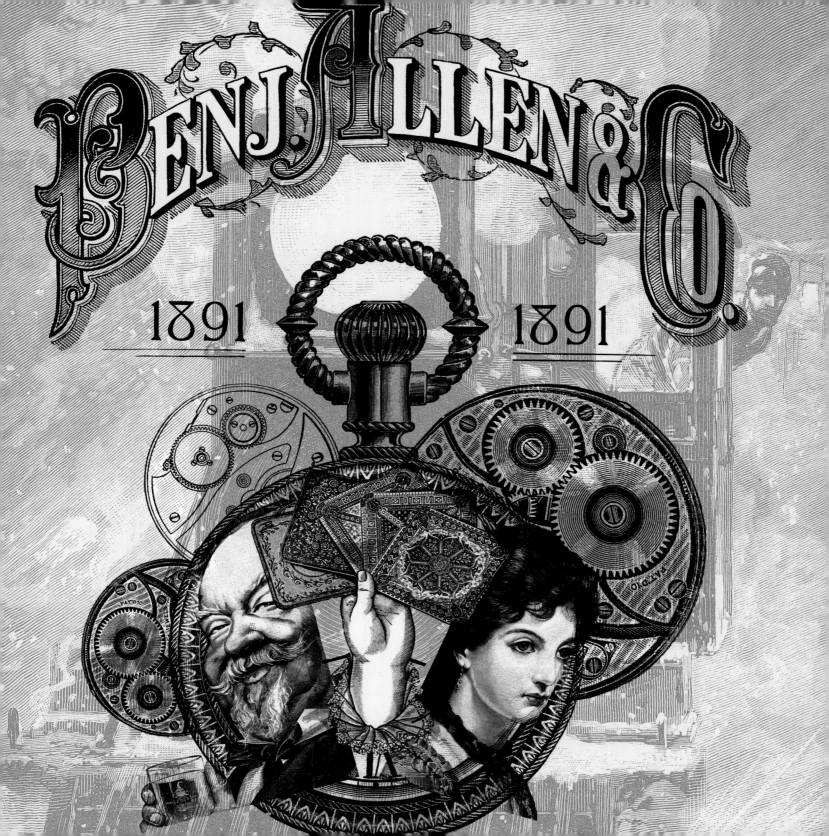

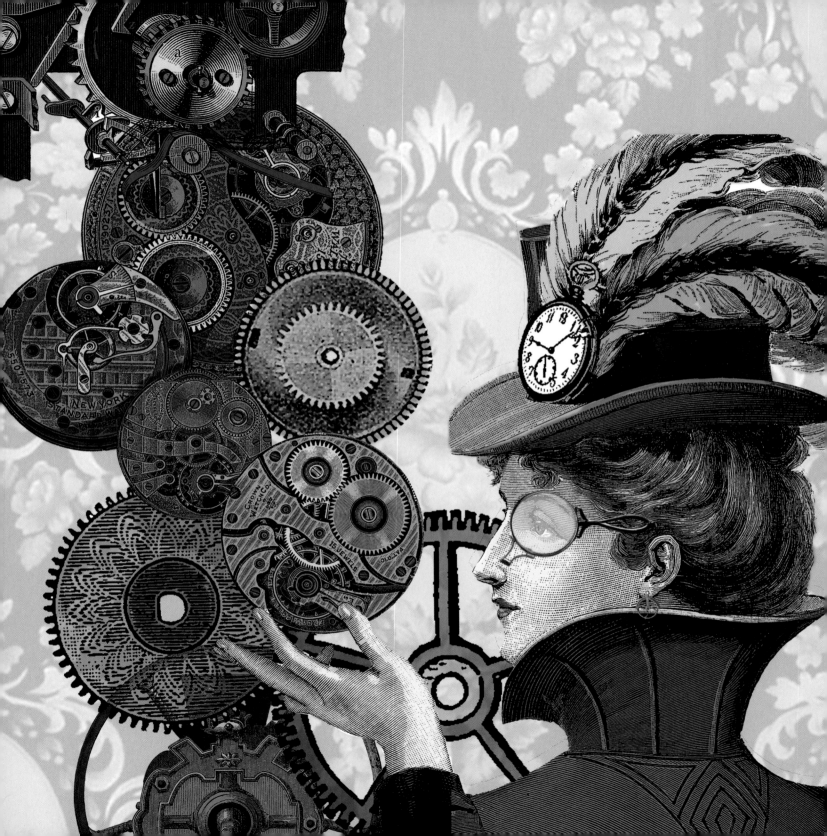

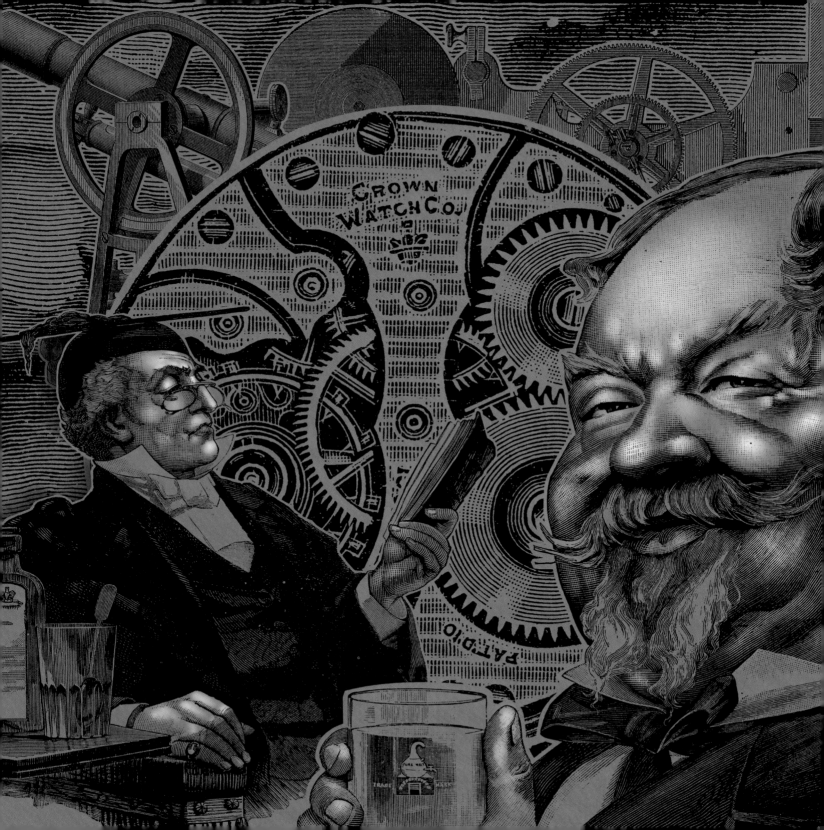

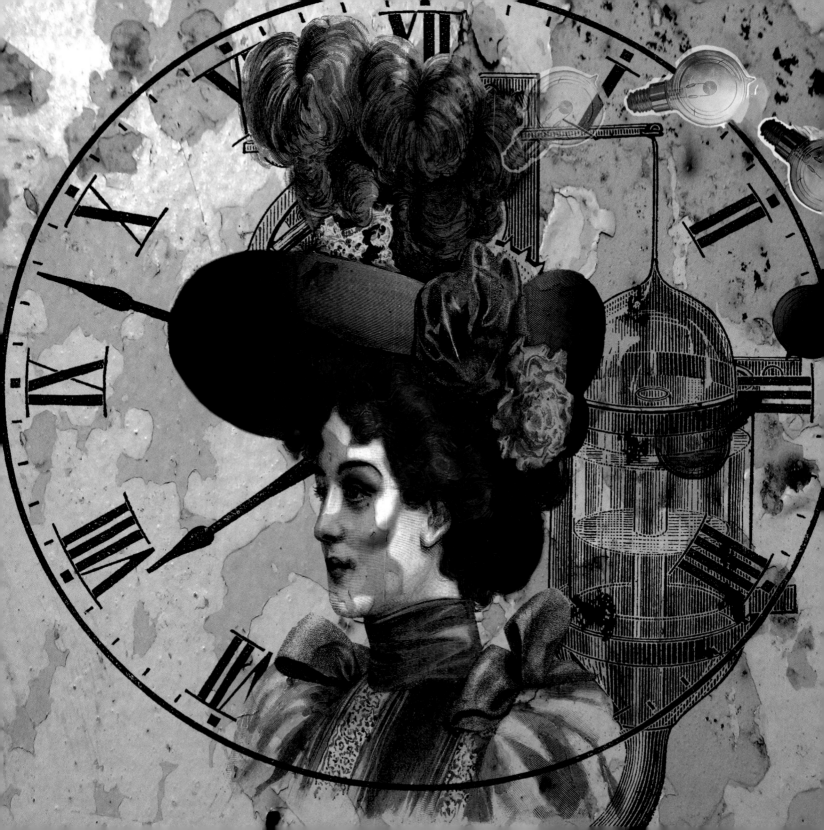

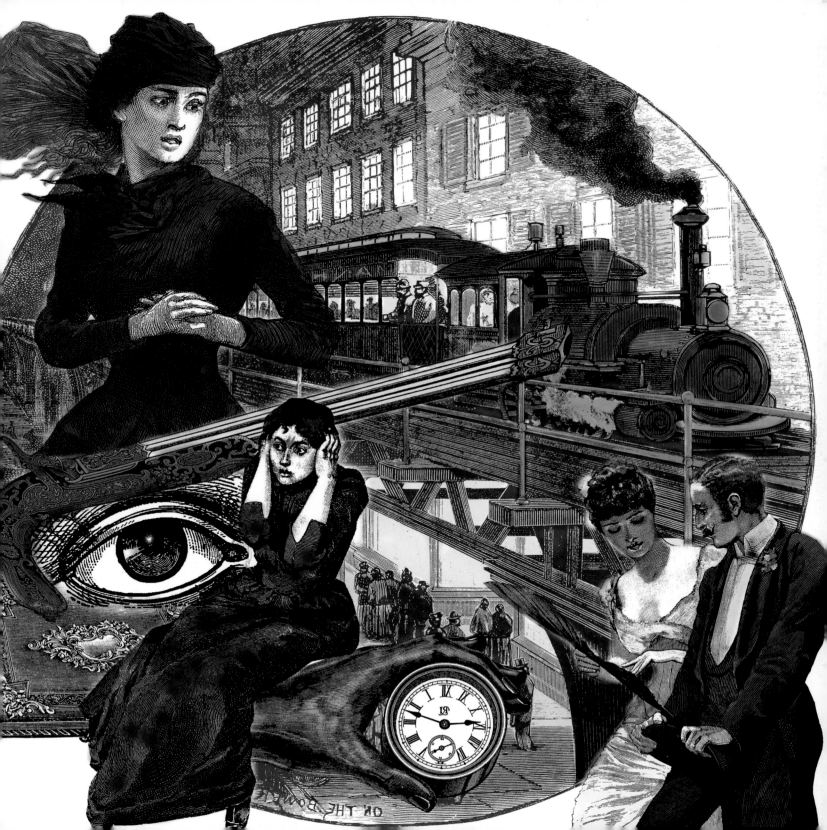

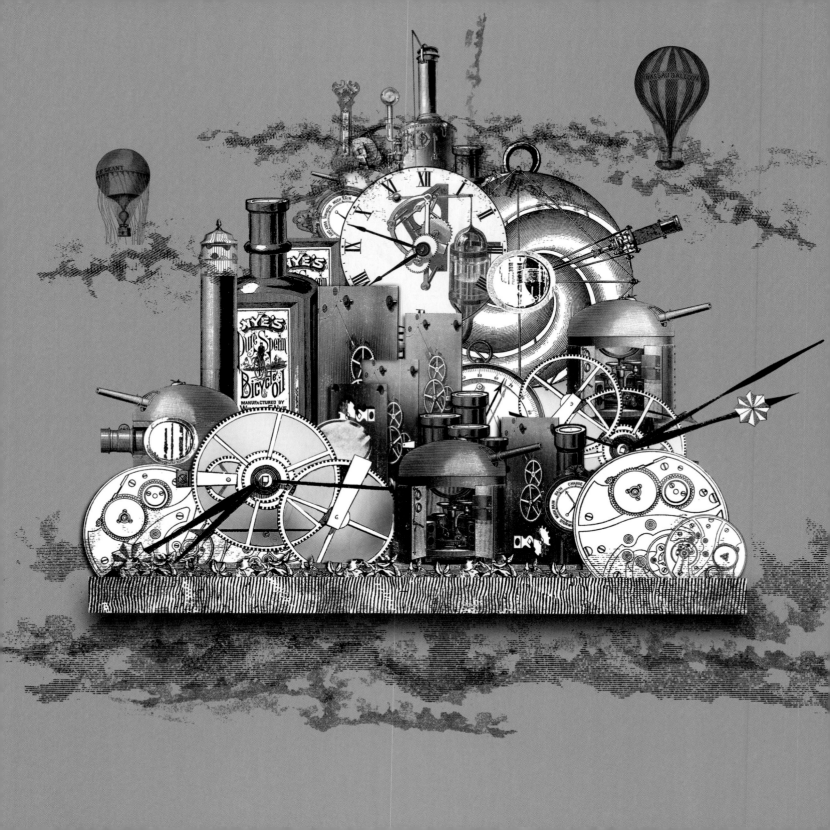

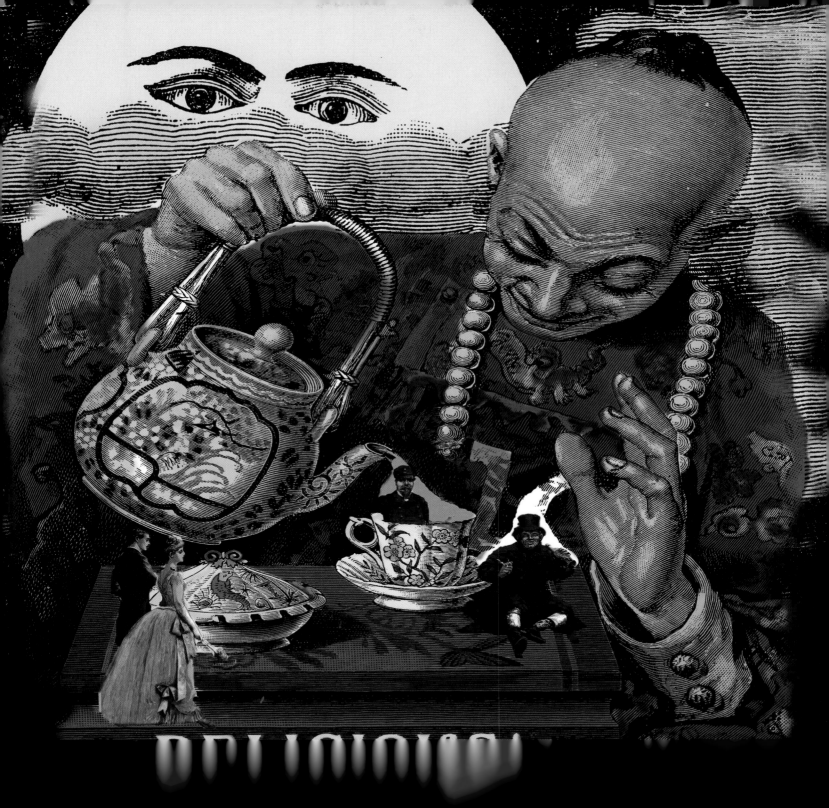

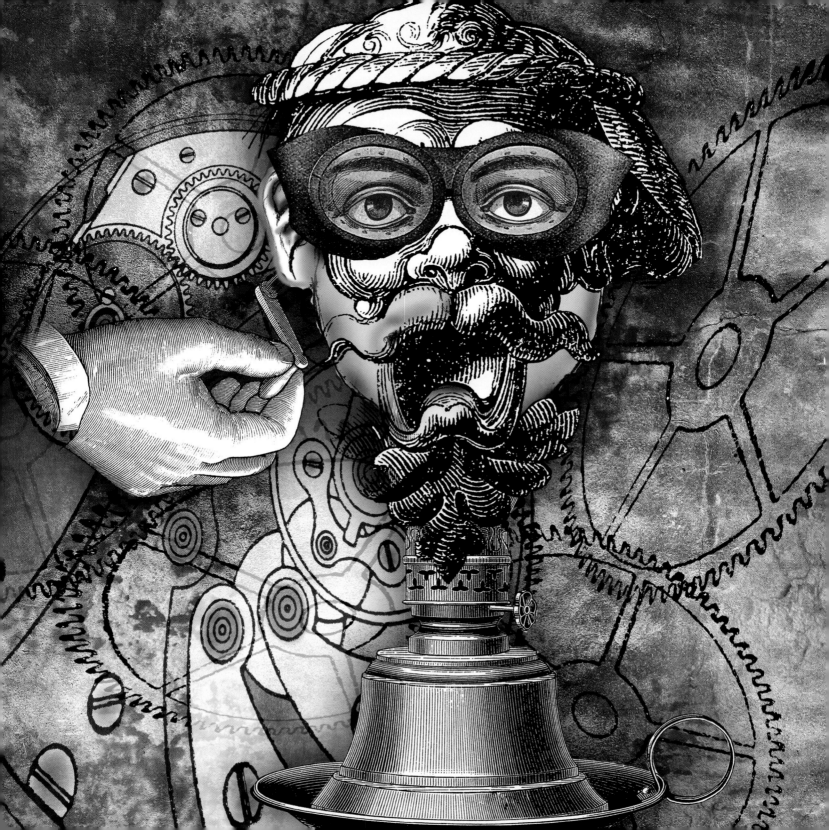

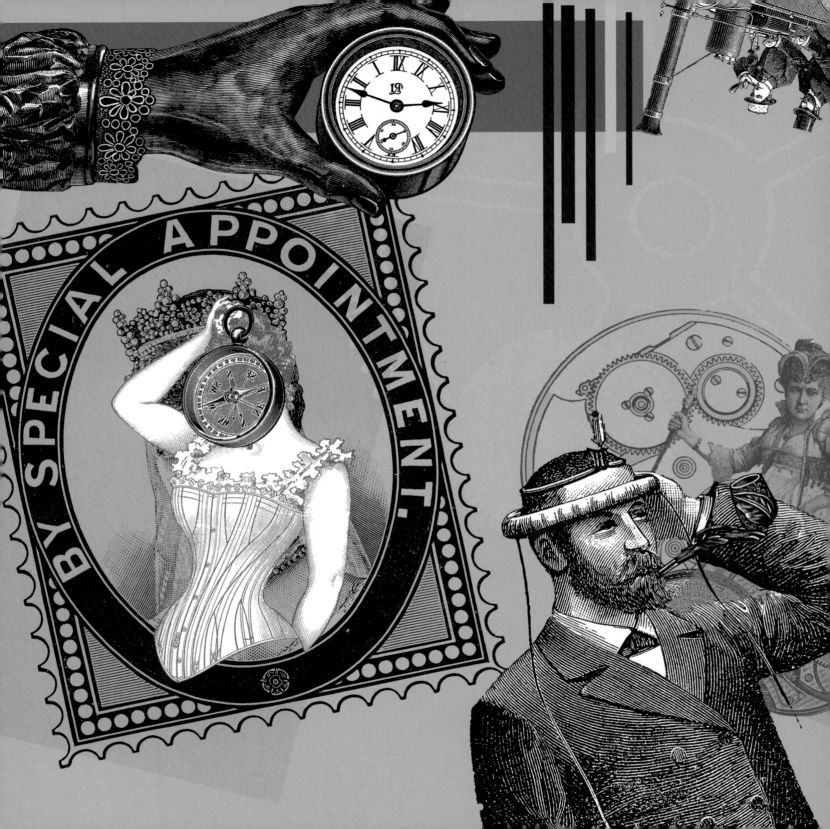

BY SPECIAL APPOINTMENT.

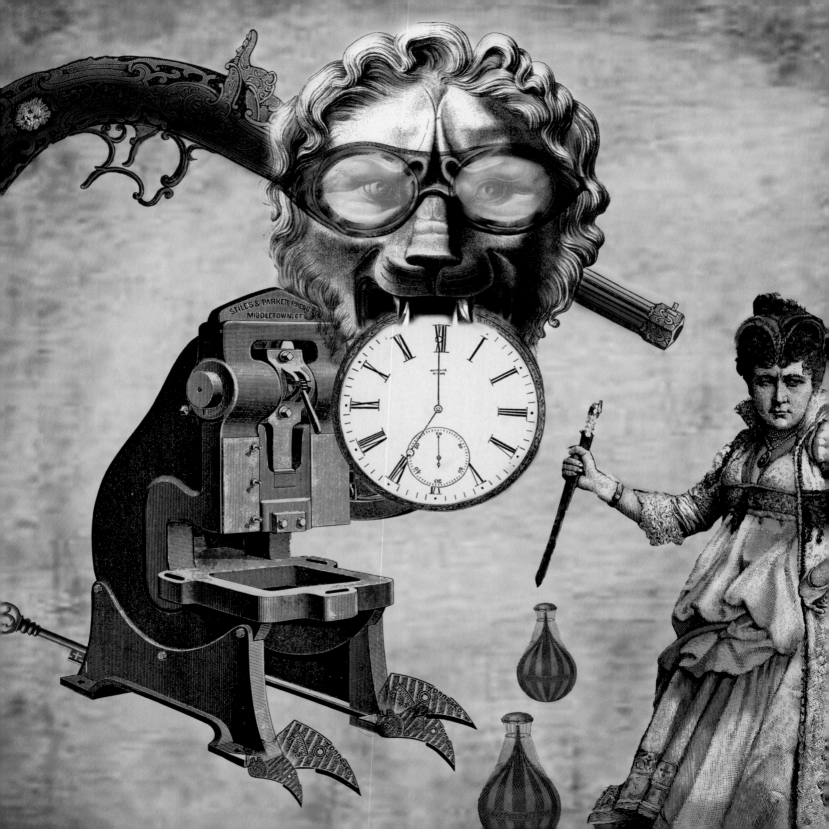

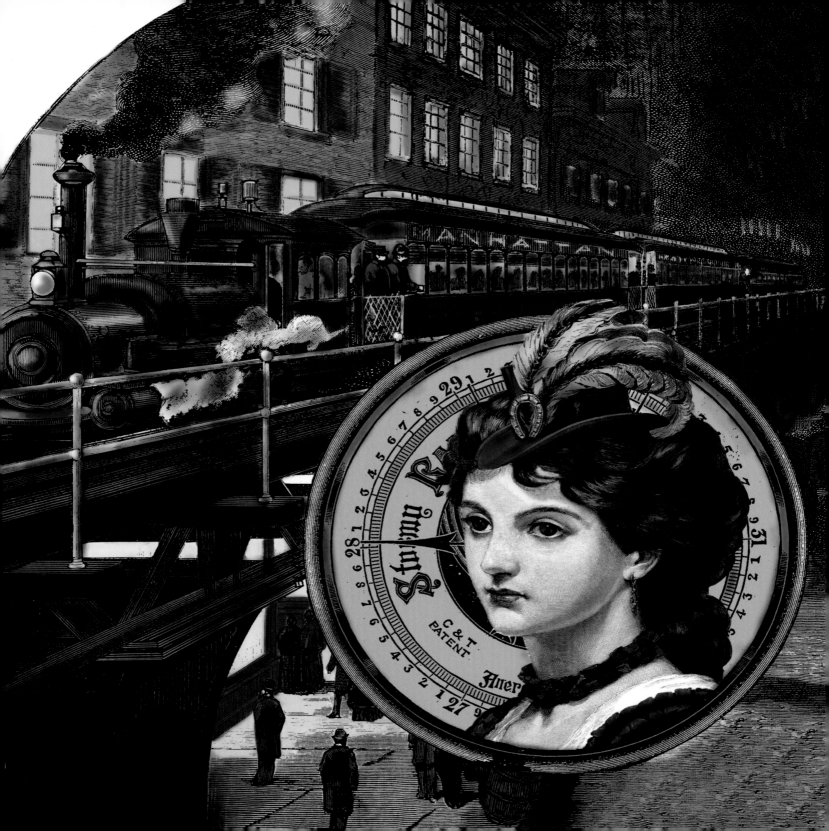

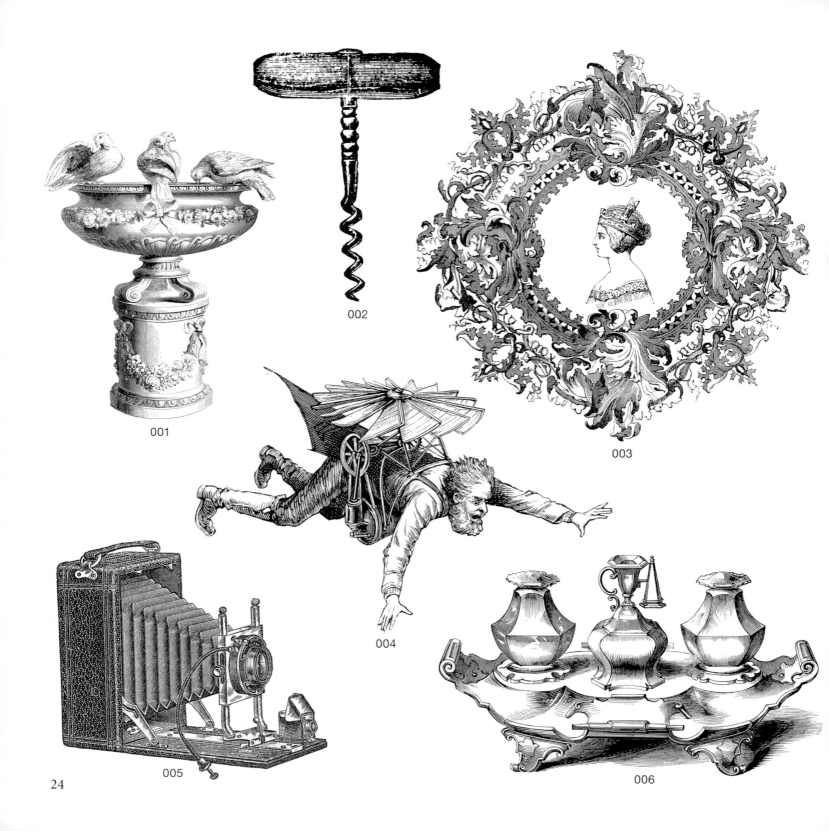

001

002

003

004

005

006

24

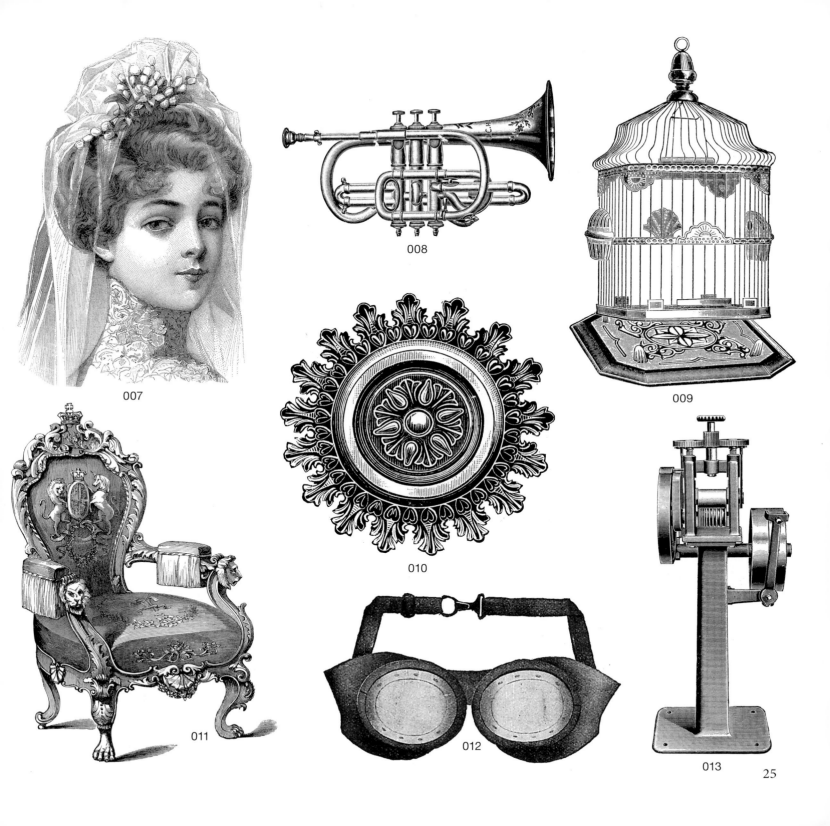

007

008

009

010

011

012

013

25

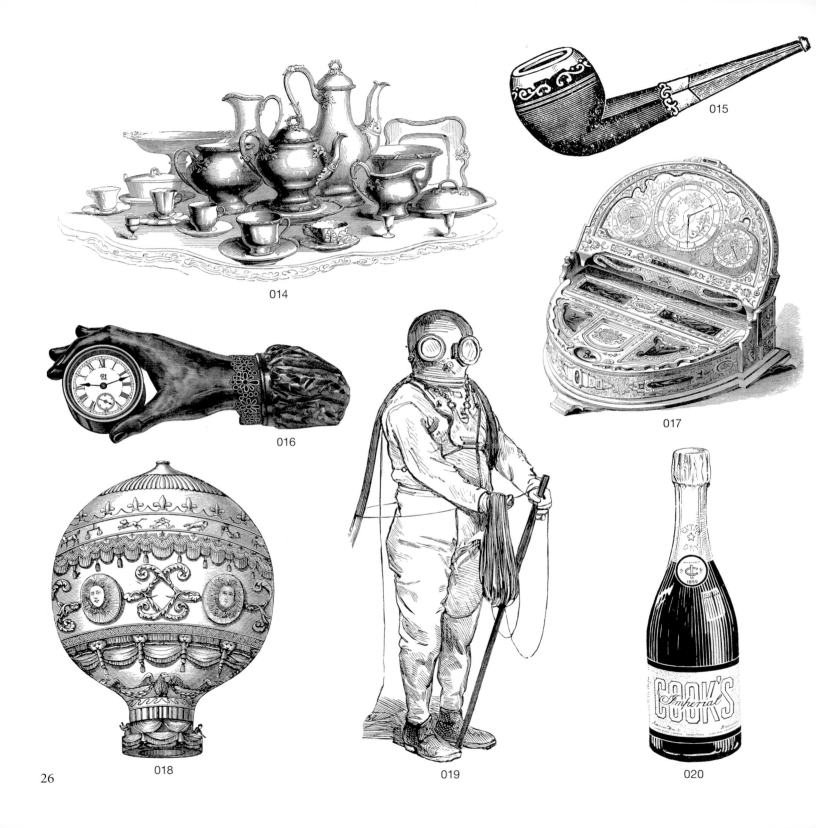

014

015

016

017

018

019

020

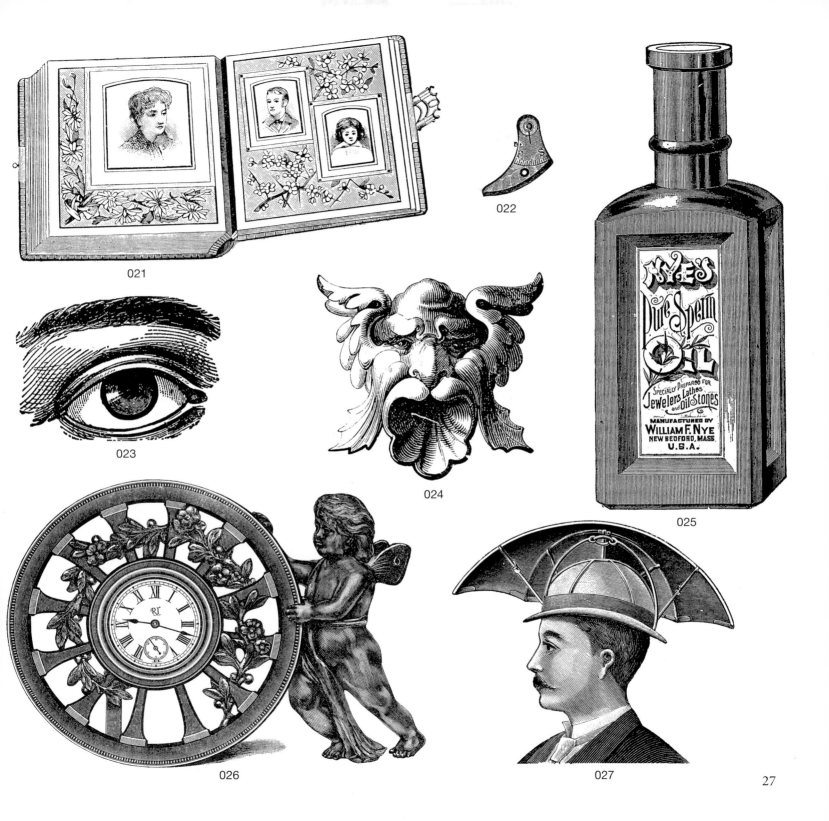

021

022

023

024

NYE'S
Pure Sperm
OIL
SPECIALLY PREPARED FOR
Jewelers Lathes
and Oil Stones
MANUFACTURED BY
WILLIAM F. NYE
NEW BEDFORD, MASS.
U.S.A.

025

026

027

27

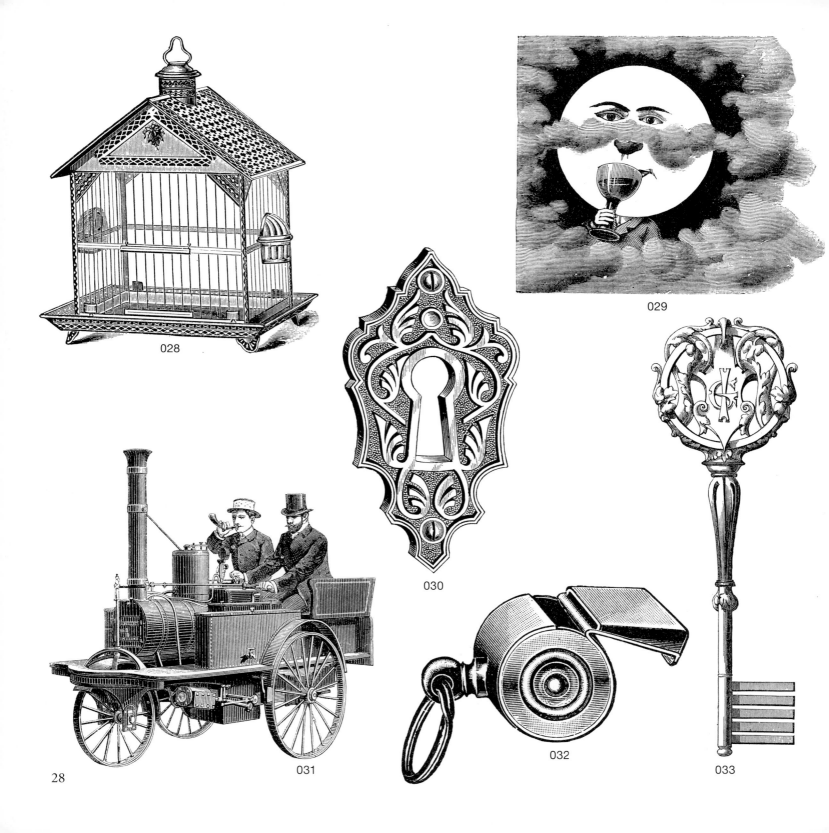

028

029

030

28 031 032 033

034

035

036

037

038

039

040

041

042

043

044

045

QUEECHY

046

047

048

049

050

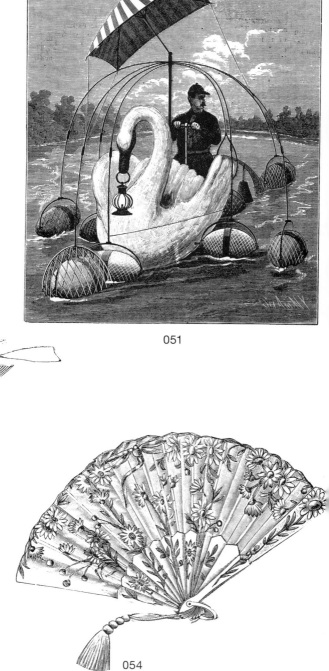

051

052

053

054

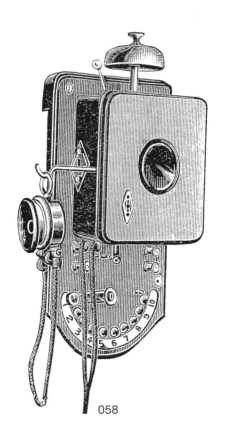

055

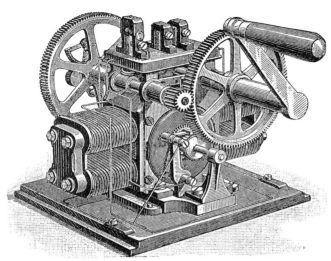

056

057

058

059

060

061

062

063

064

065

066

067

068

069

070

35

071

072

073

074

075

076

077

078

079

080

081

082

37

083

084

085

086

087

088

089

090

091

092

093

094

39

095

096

097

098

099

40

100

101

102

103

104

105

106

107

108

109

110

111

42

112

113

114

115

116

117

118

119

120

121

122

123

44

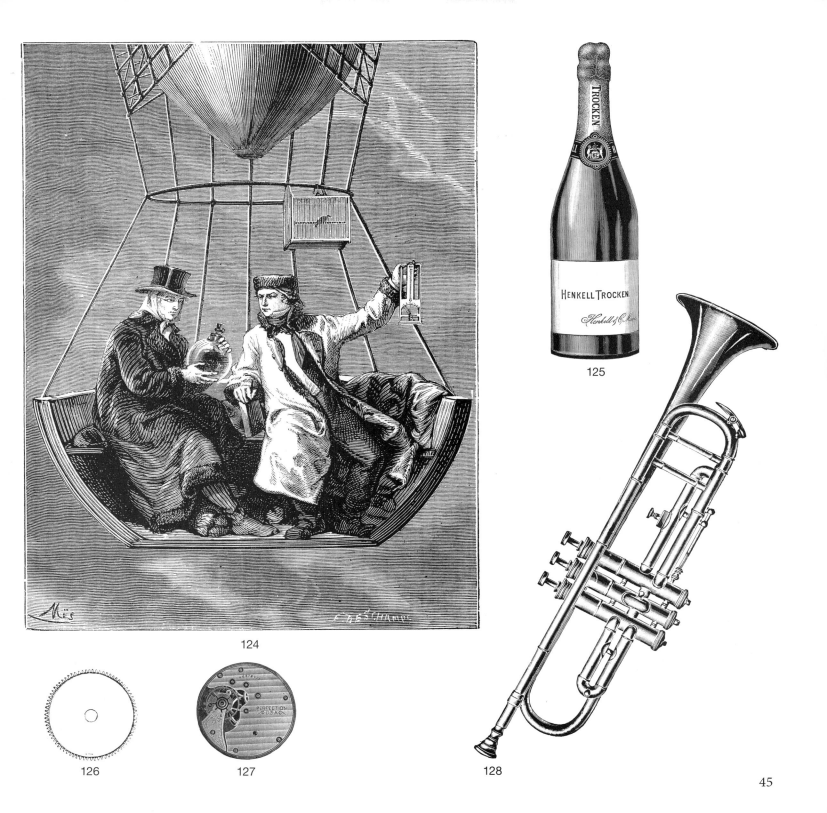

124

125

126

127

128

129

131

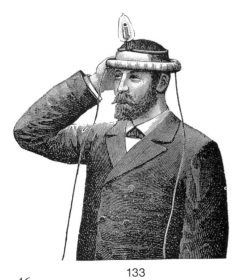

133

130

134

132

135

136

137

138

139

140

141

142

143

144

145

146

147

148

149

150

151

49

152

153

154

155

156

157

50

158

159

160

161

162

163

51

164

165

166

167

168

169

170

171

172

173

174

175

176

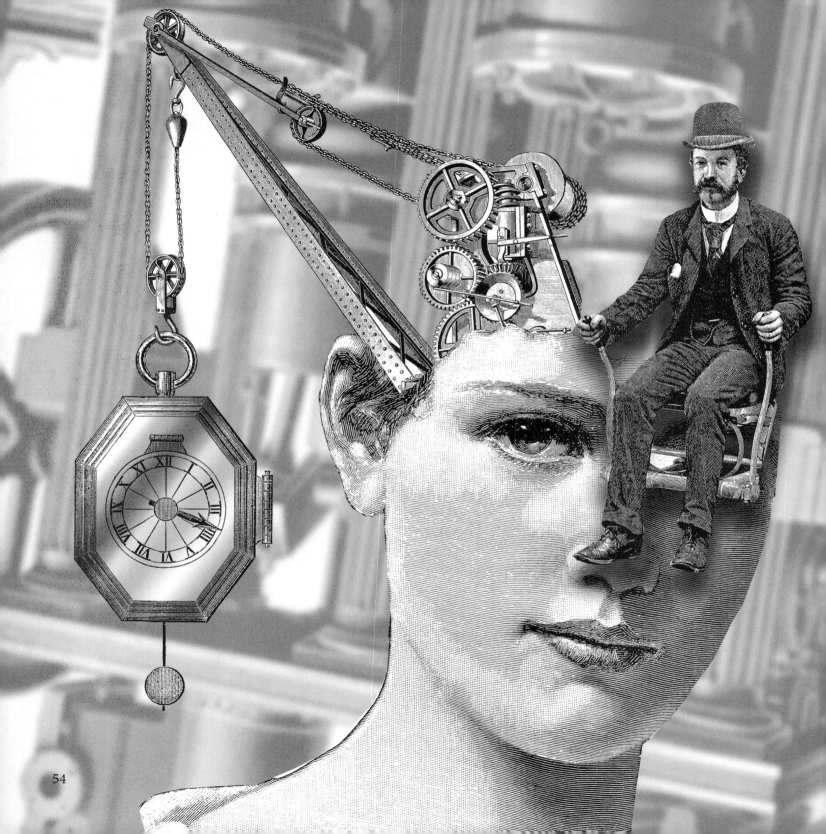

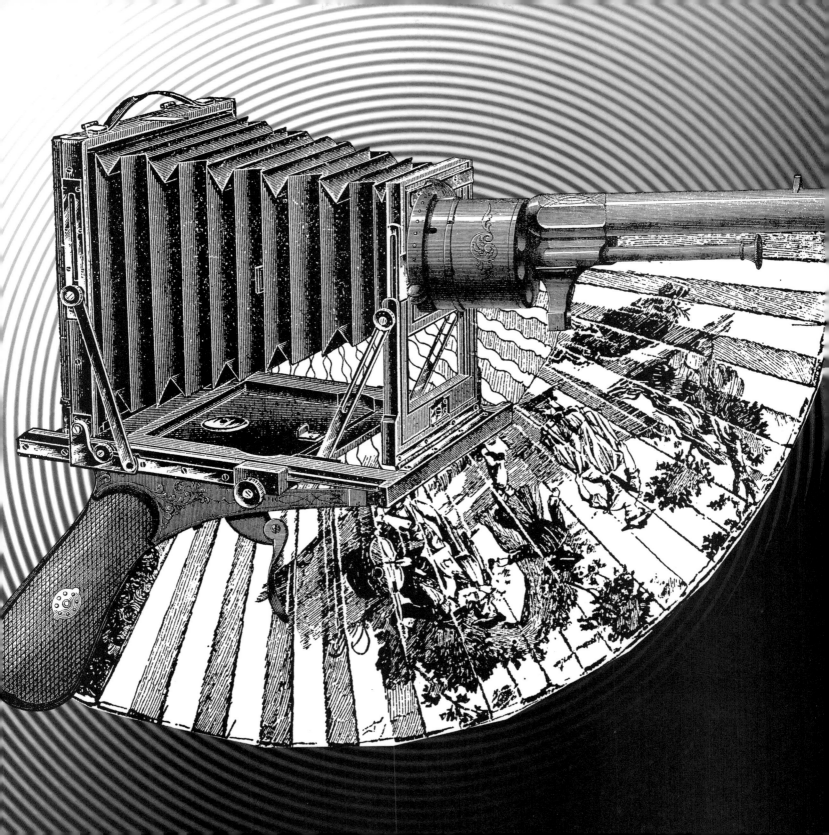

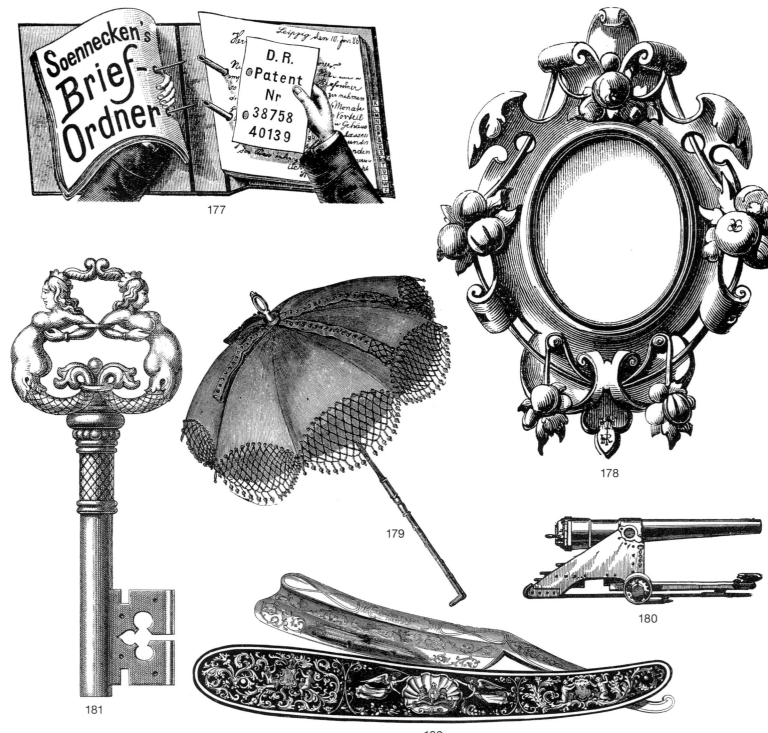

Soennecken's
Brief-
Ordner

D. R.
Patent
Nr
38758
40139

177

178

179

180

181

182

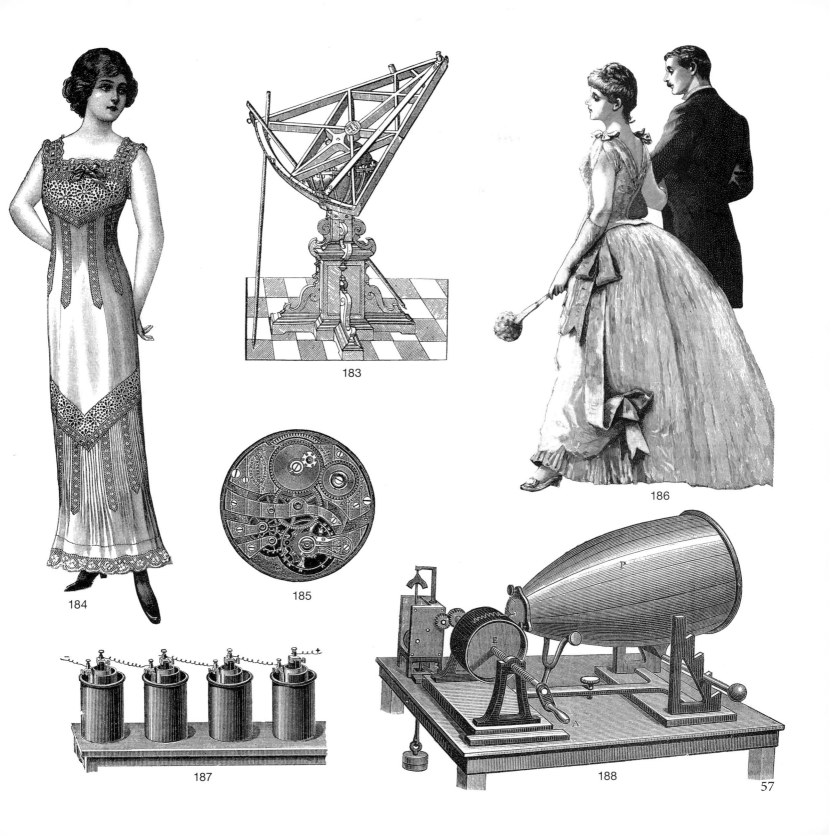

184

183

185

186

187

188

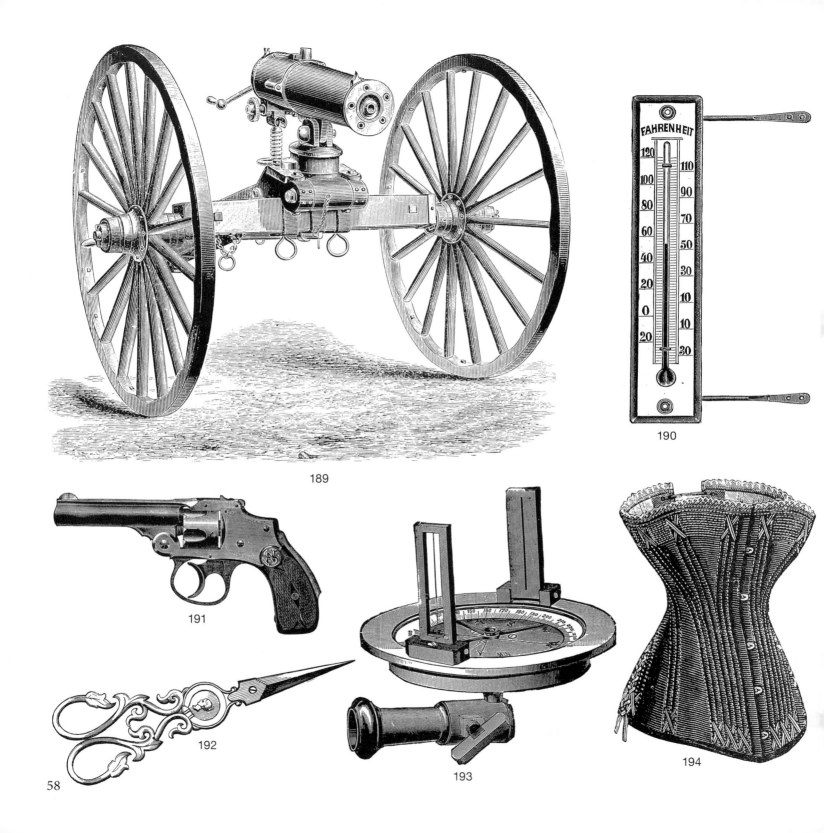

189

190

191

192

58

193

194

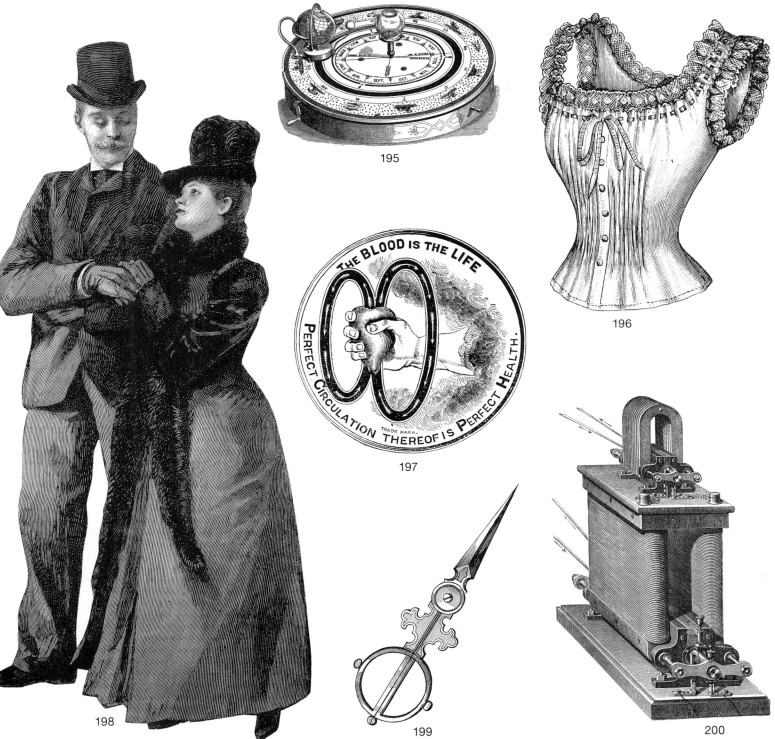

195

196

THE BLOOD IS THE LIFE

PERFECT CIRCULATION THEREOF IS PERFECT HEALTH.

TRADE MARK.

197

198

199

200

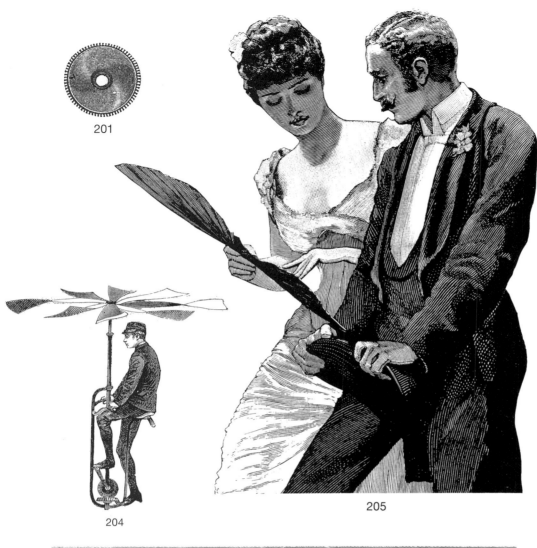

201

202

203

204

205

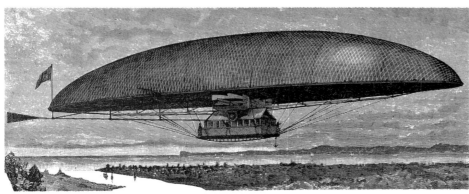

206

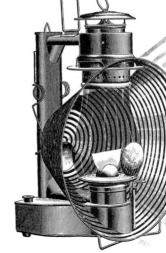

207

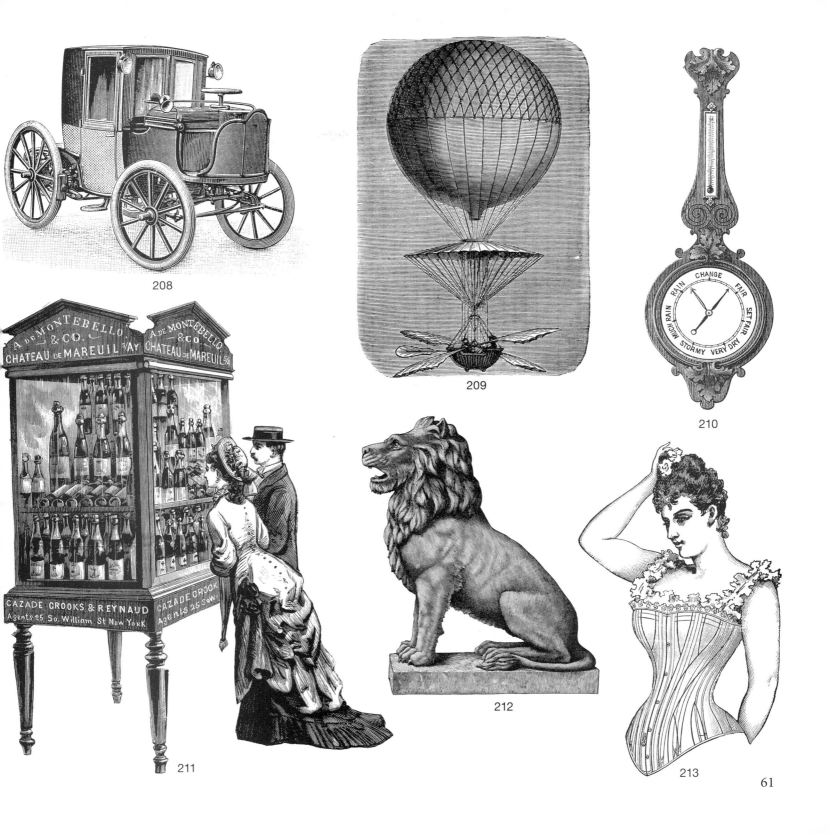

208

209

210

211

212

213

61

214

215

216

217

218

219

220

62

221

222

223

224

225

226

SIDE VIEW
SHOWING THICKNESS

227

228

229

230

231

232

233

234

235

236

237

238

239

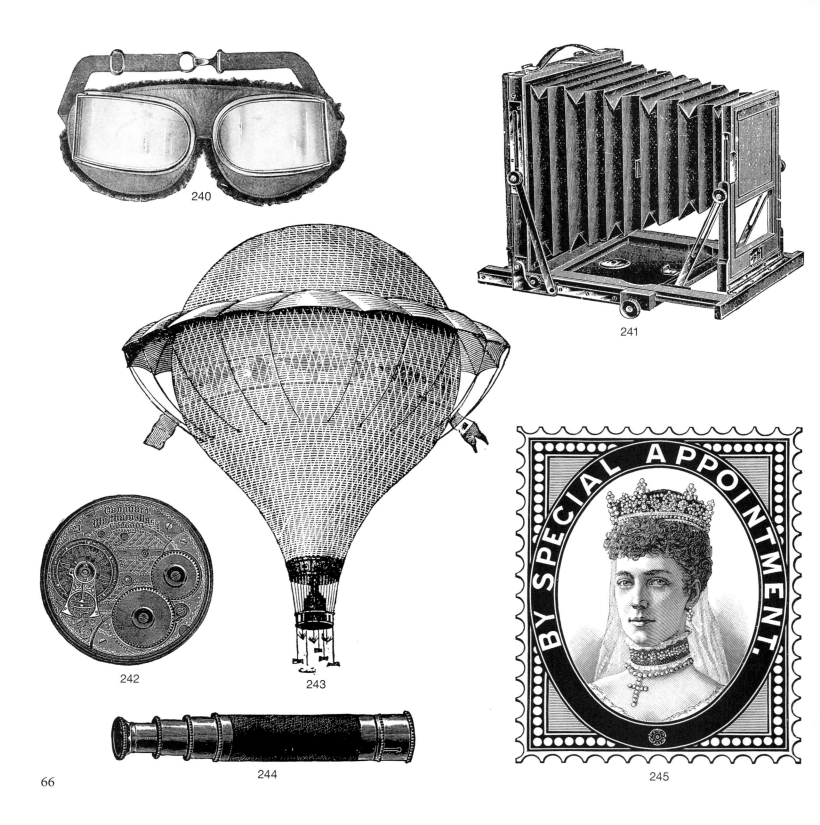

240

241

242

243

244

245

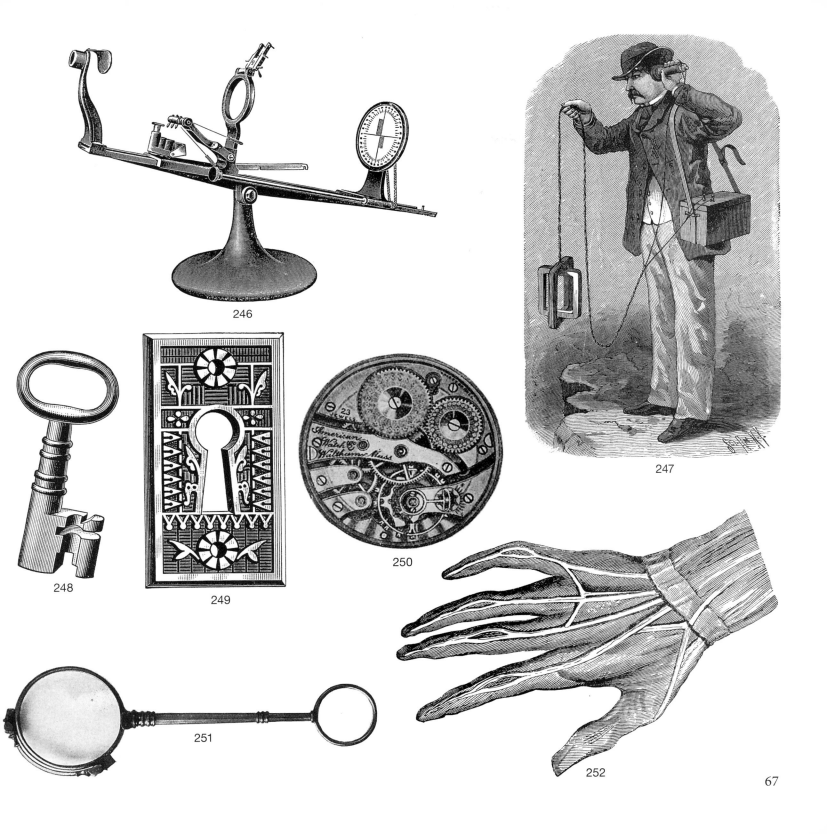

246

247

248

249

250

251

252

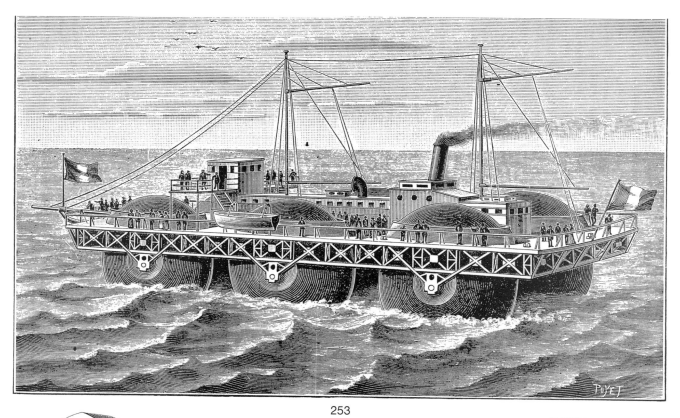

253

256

254

257

258

255

259

260

261

262

263

264

265

266

267

268

269

270

70

271

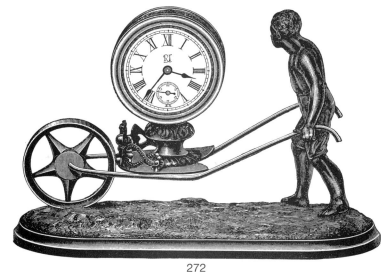

272

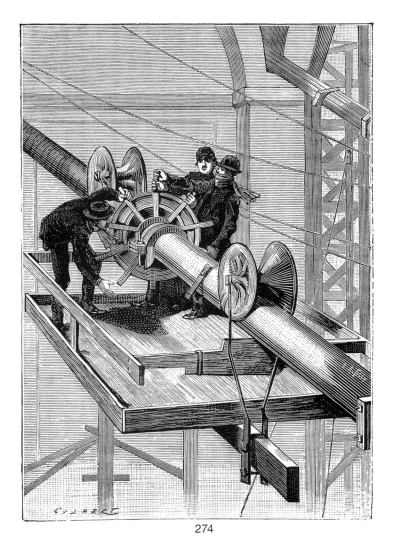

274

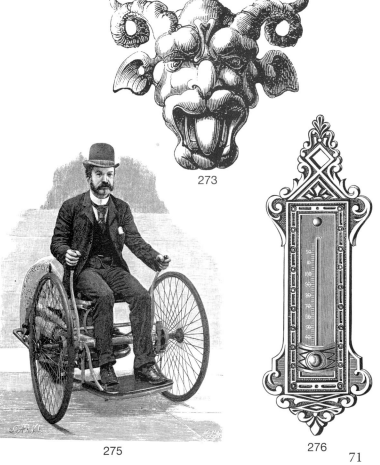

273

275

276

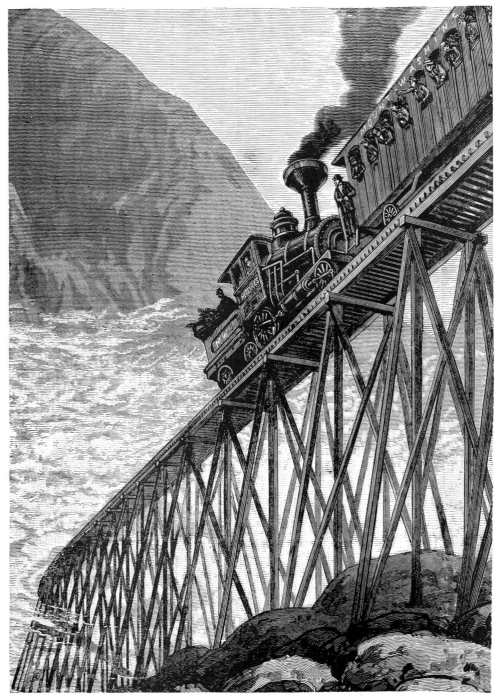

277

278

279

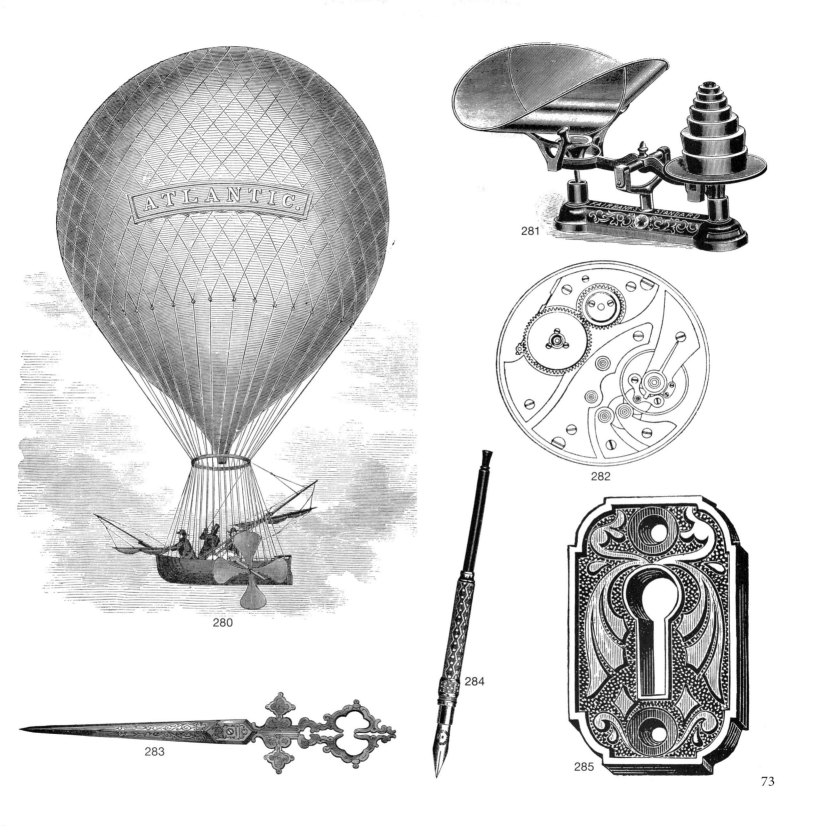

ATLANTIC.

280

281

282

283

284

285

73

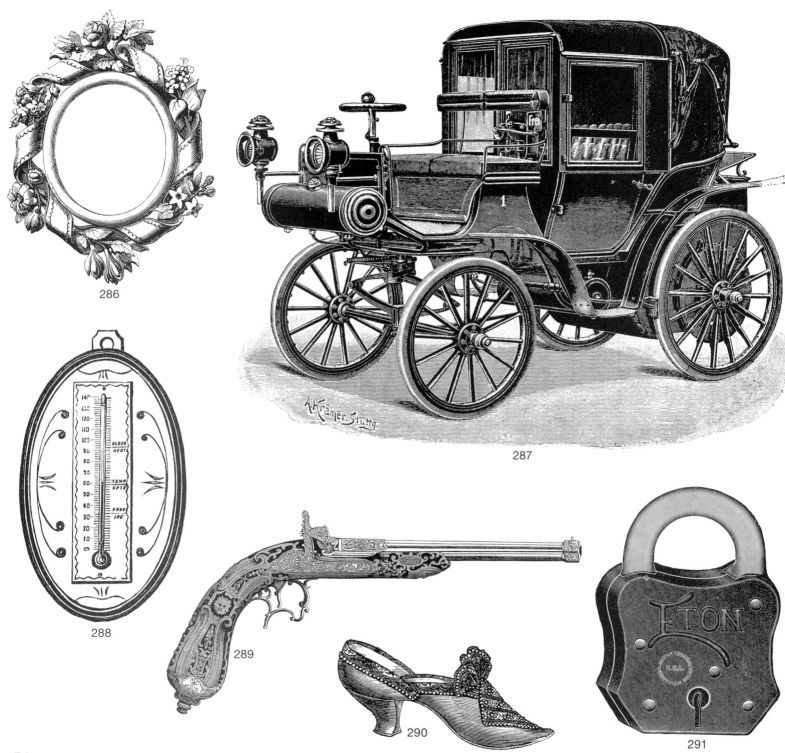

286

287

288

289

290

291

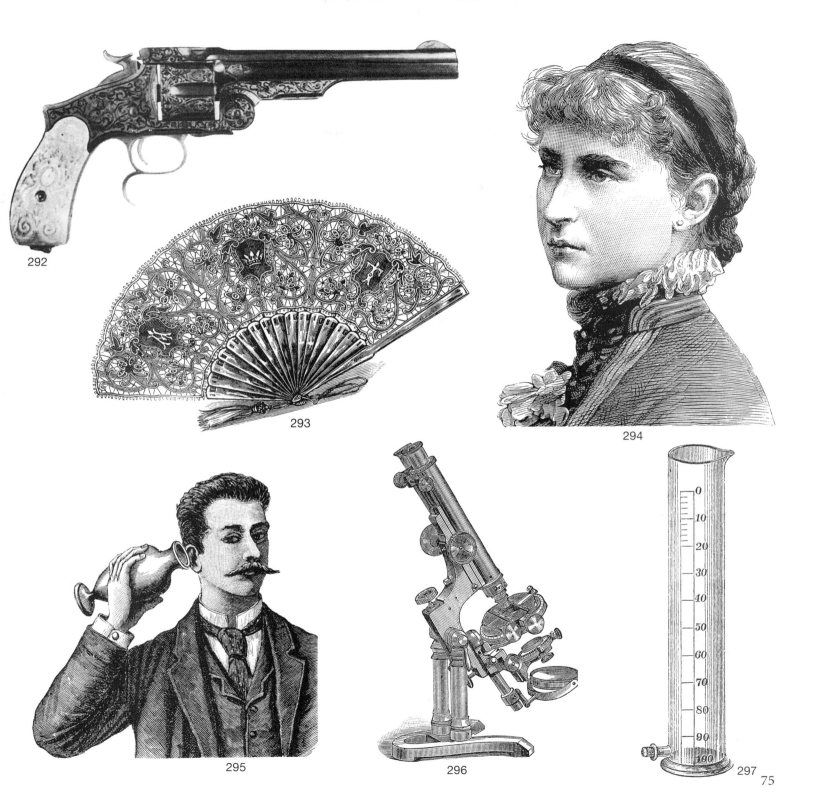

292

293

294

295

296

297

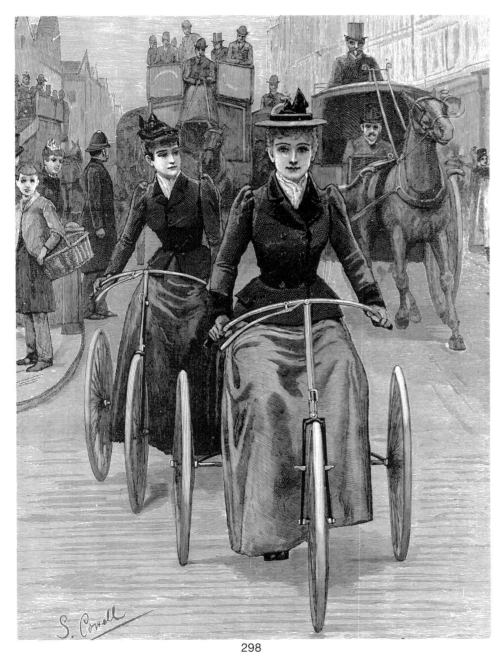

298

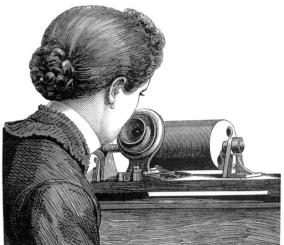

299

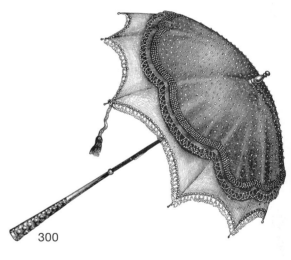

300

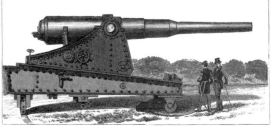

301

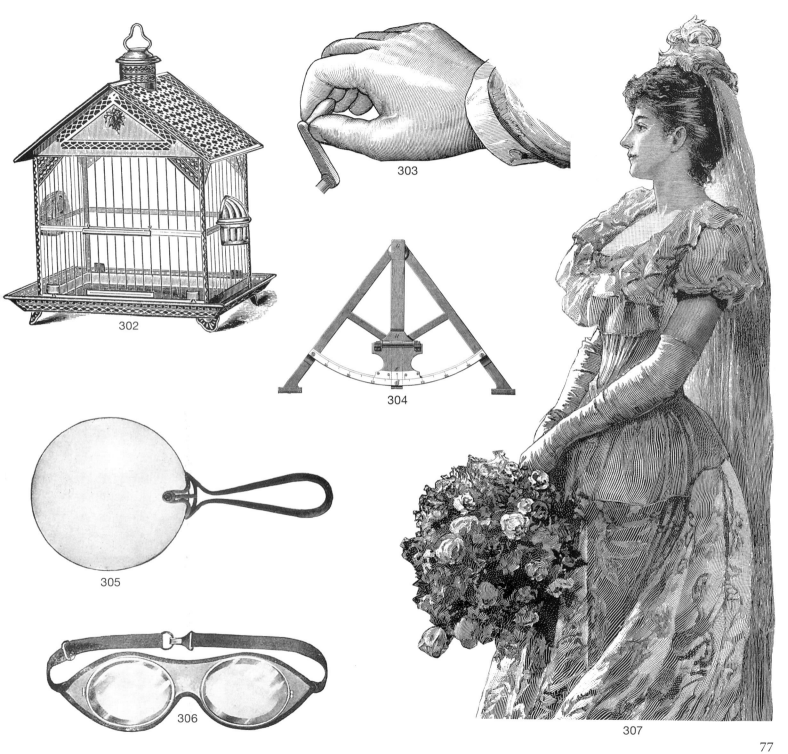

302

303

304

305

306

307

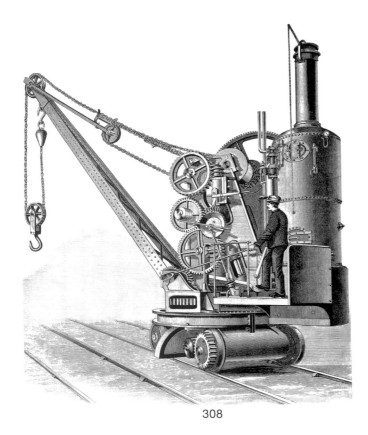

308

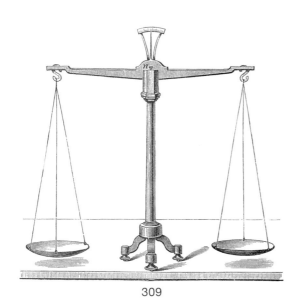

309

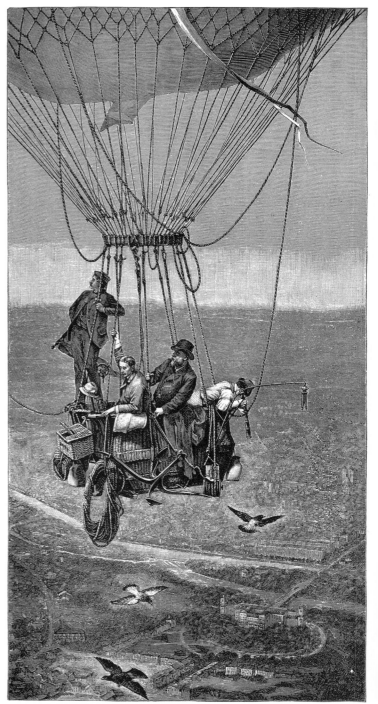

310

311

312

313

314

315

316

317

79

318

319

320

321

322

323

324

325

HARTSHORN'S
Self Acting
Shade Rollers.

326

FAVORITE

327

328

329

330

331

Concert Roller Organ

332

333

82

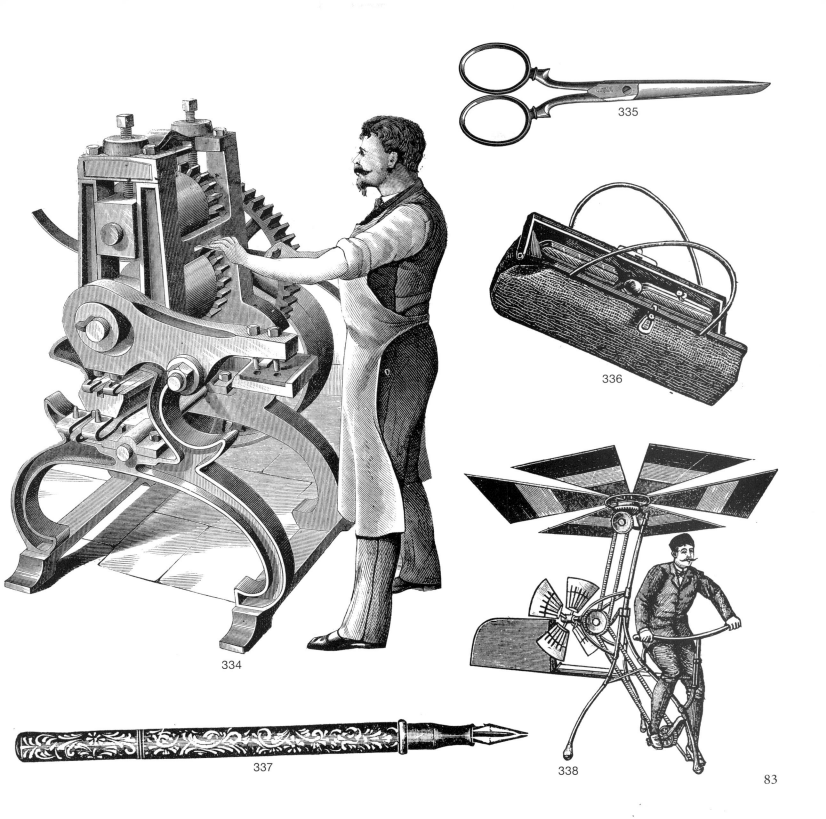

334

335

336

337

338

83

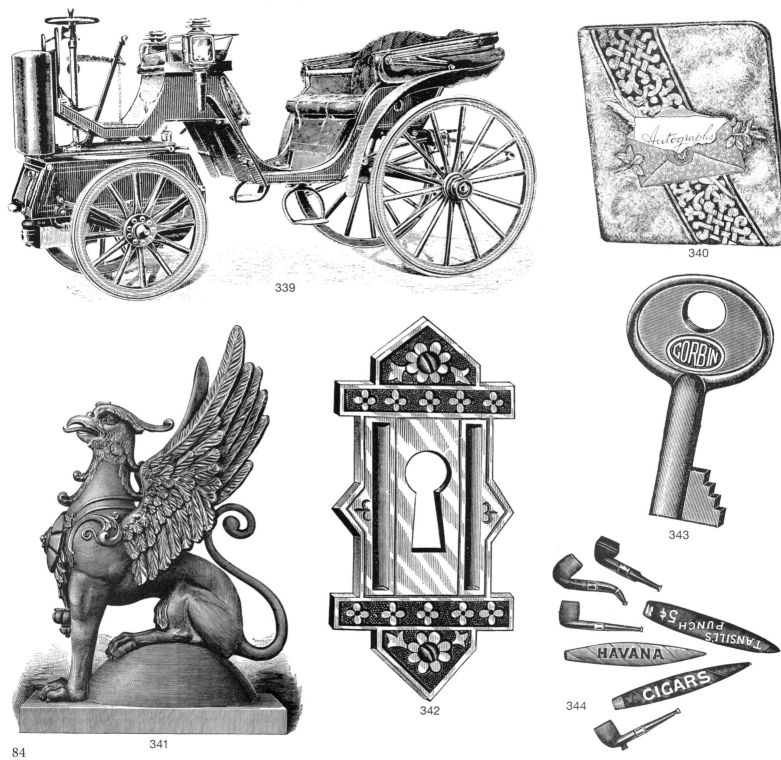

339

340

341

342

343

344

345

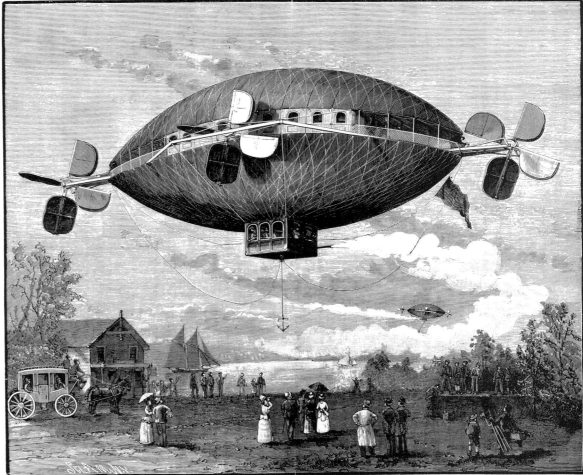

346

347

348

349

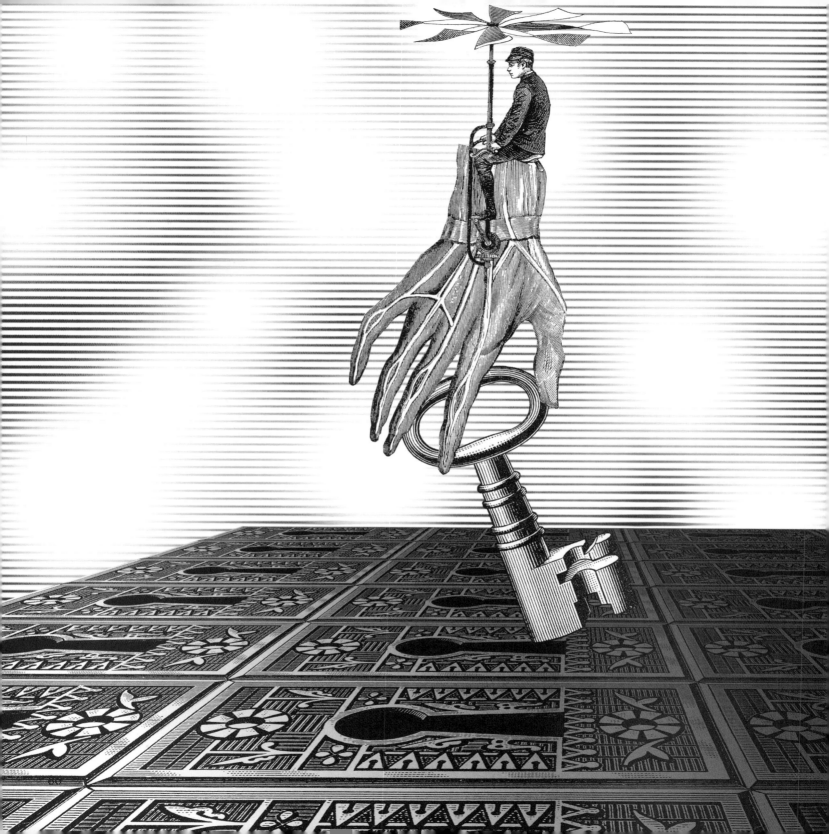

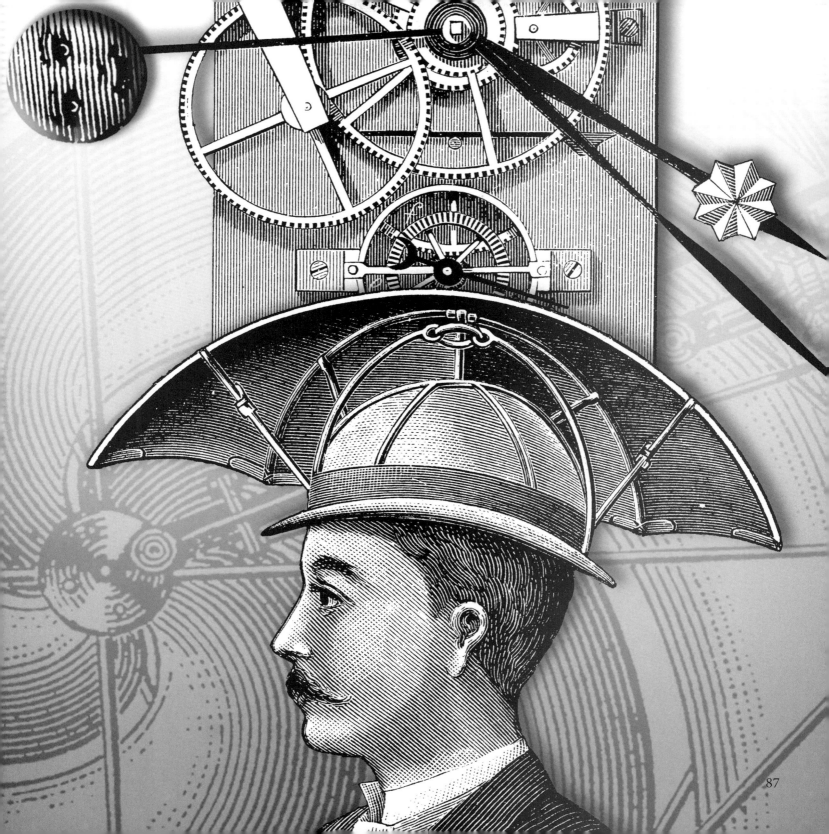

350

351

352

353

354

355

356

357

358

359

360

361

89

362

363

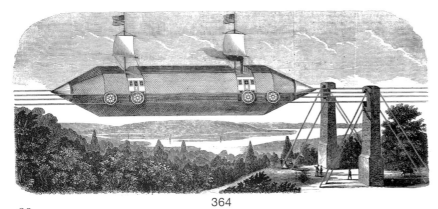

364

365

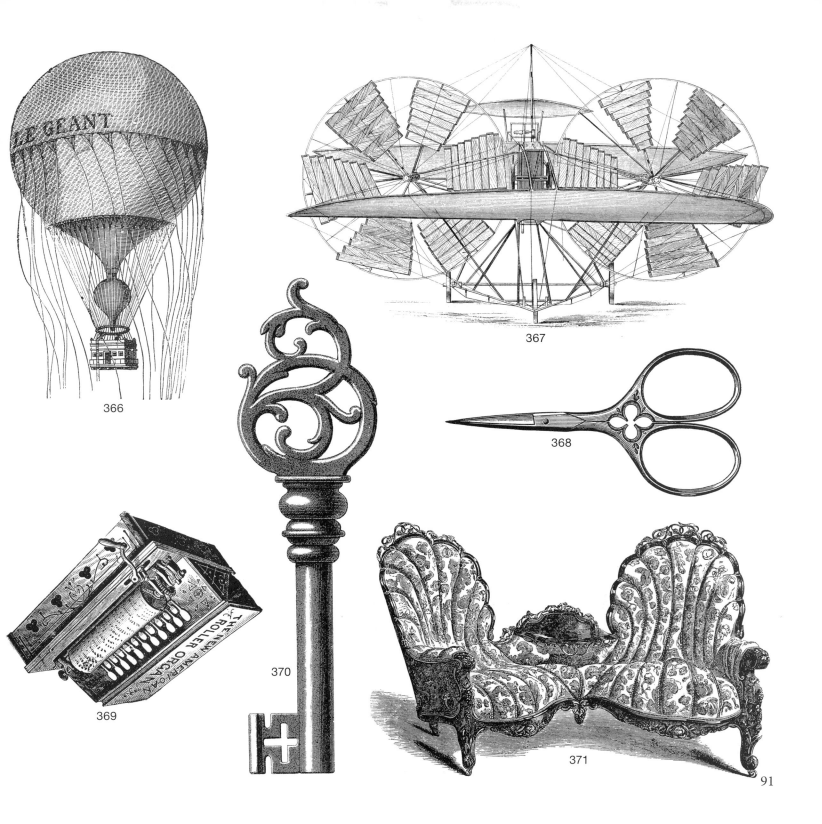

366

367

368

369

370

371

91

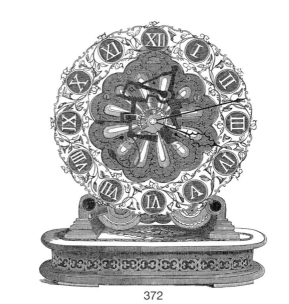

372

373

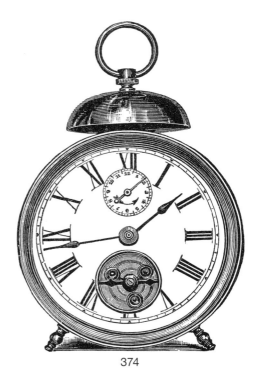

374

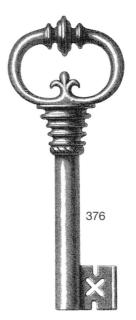

376

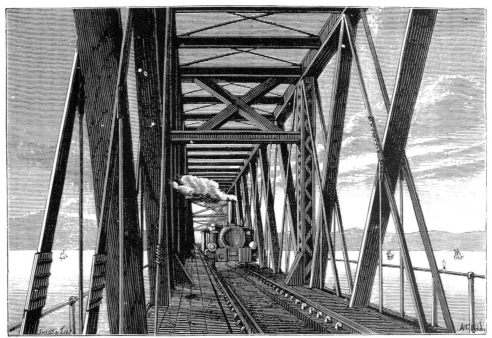

377

375

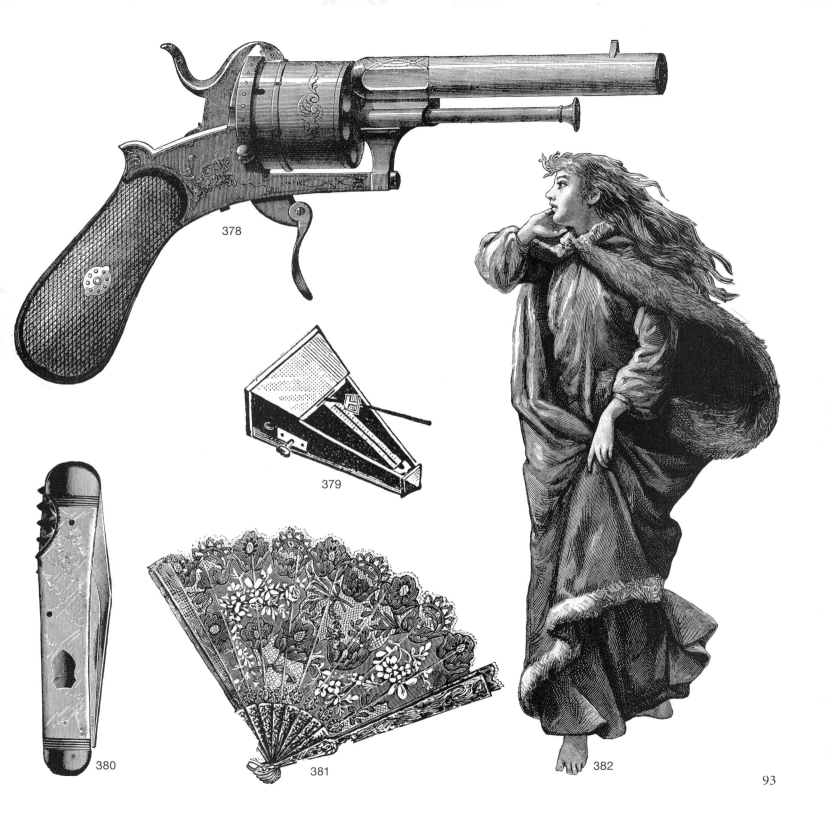

378

379

380

381

382

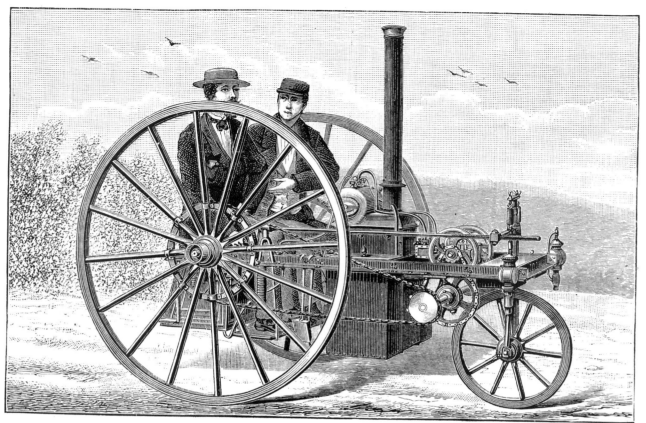

383

384

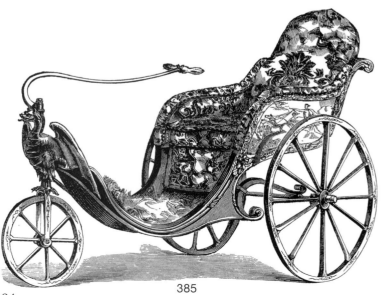

385

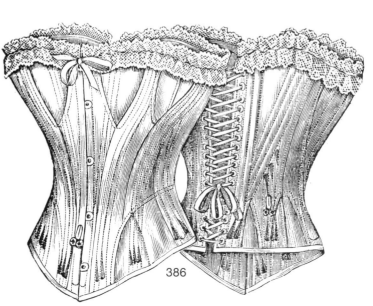

386

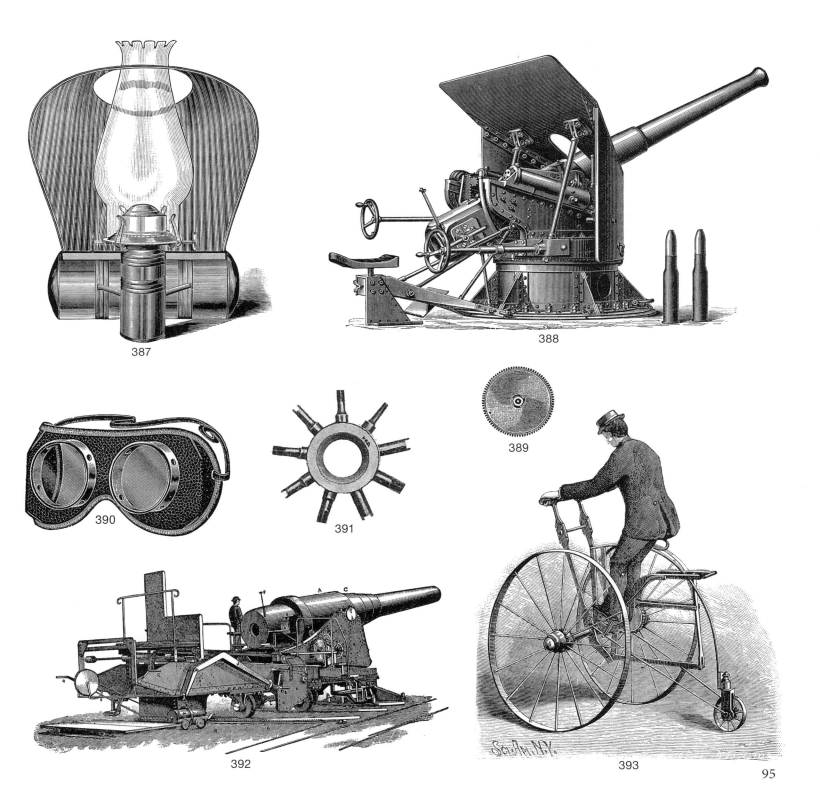

387

388

390

391

389

392

393

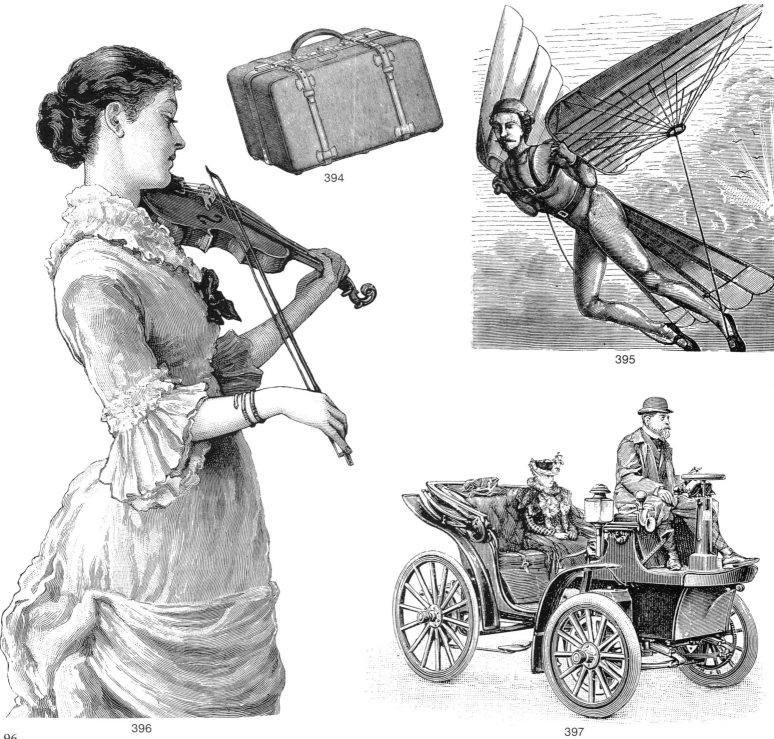

394

395

396

397

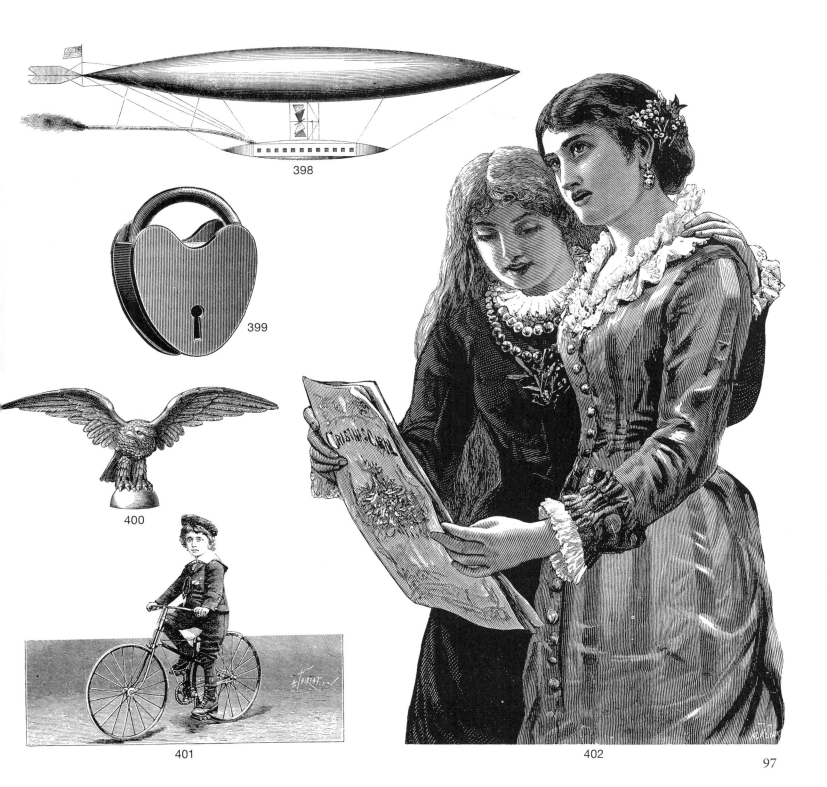

398

399

400

401

402

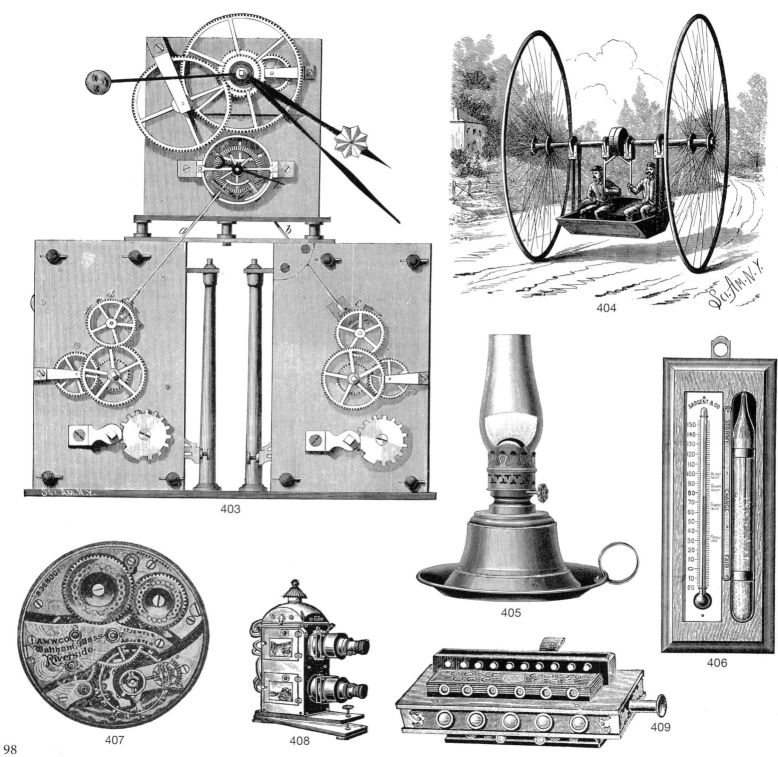

403

404

405

406

407

408

409

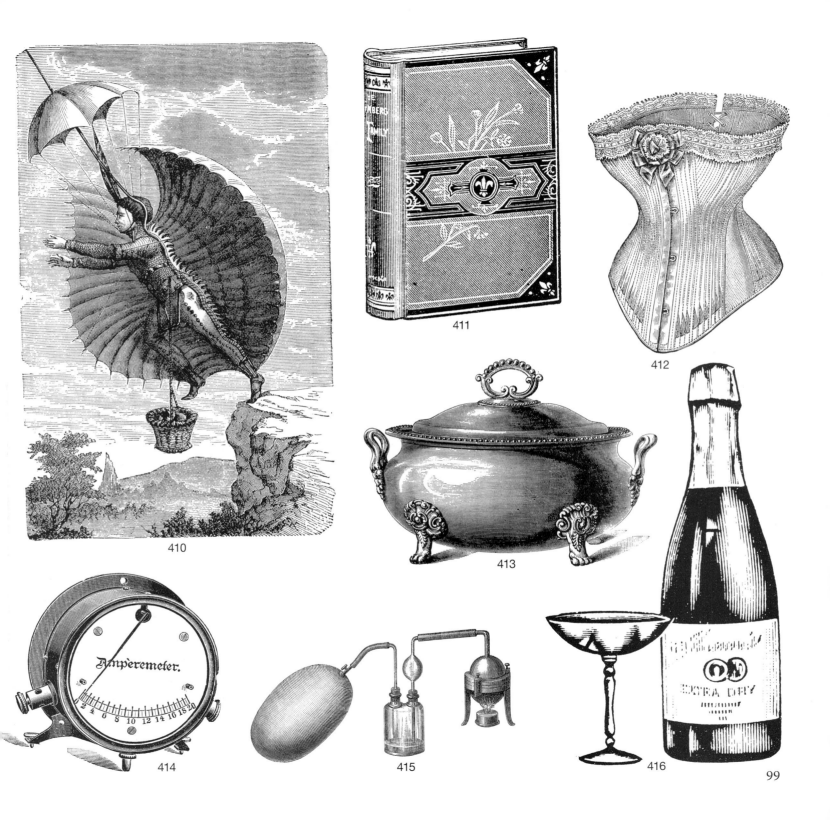

410

411

412

413

414

415

416

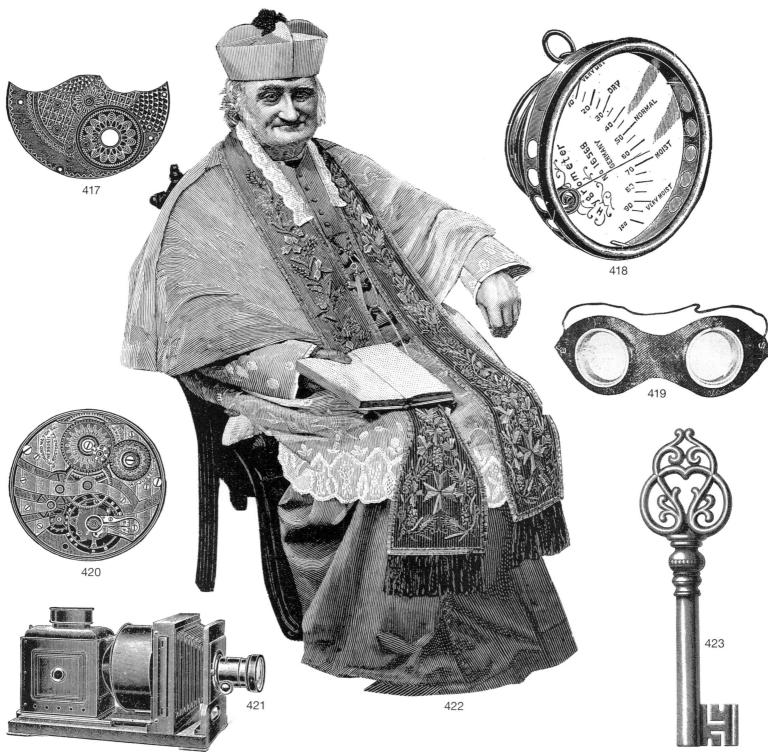

417

418

419

420

421

422

423

424

425

426

427

428

429

430

431

432

THE PETROL-CYCLE
BUTLER'S & SHUTTLEWORTH
PETROL CYCLE
SYNDICATE
LIMITED
SMITH
LONDON
PATENT

433

102

434

435

436

437

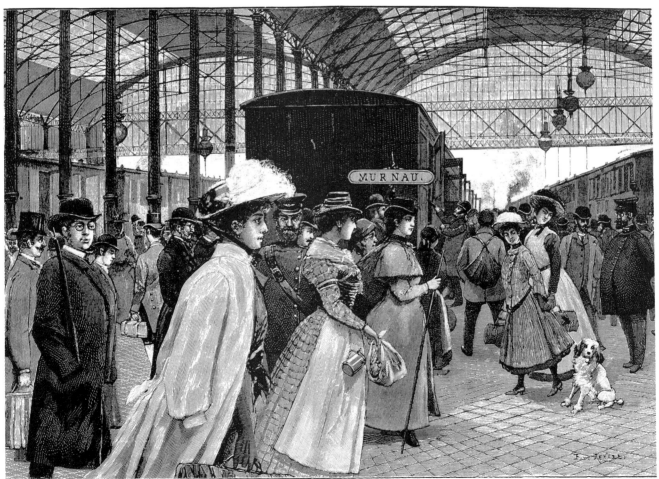

438

439

440

441

442

443

444

445

S.G.&L.CO'S
SQUARE LIFT
TUBULAR

POYET

446

447

448

449

450

WELCOME
STOVES
AND
RANGES

MAGIC
WELCOME

451

452

105

453

454

455

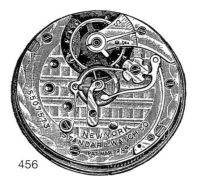

456

457

458

459

460

461

462

463

464

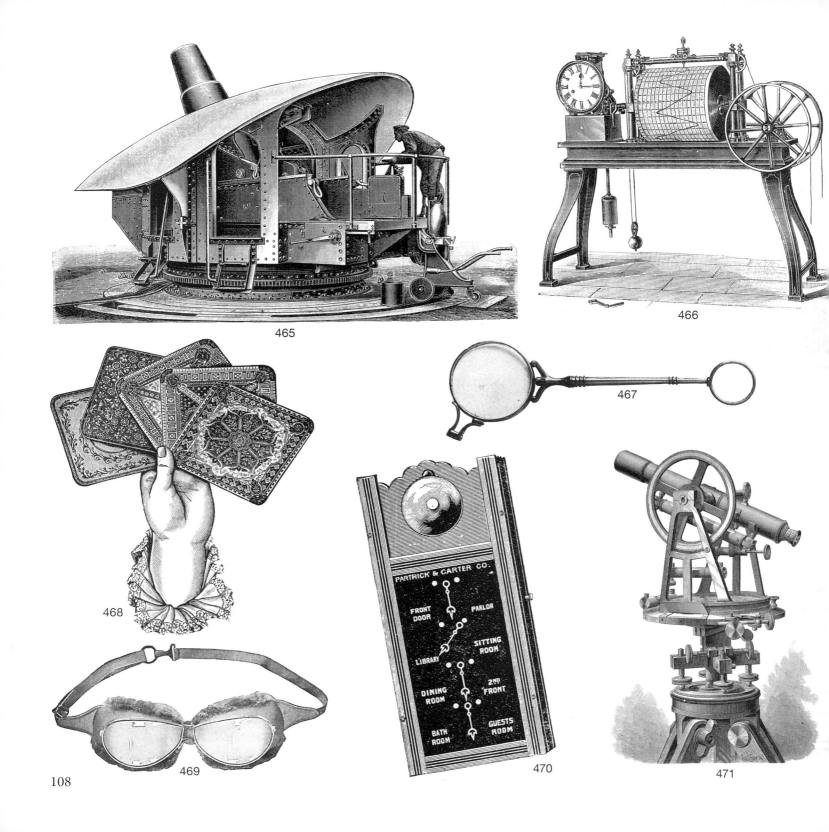

465

466

467

468

469

470

471

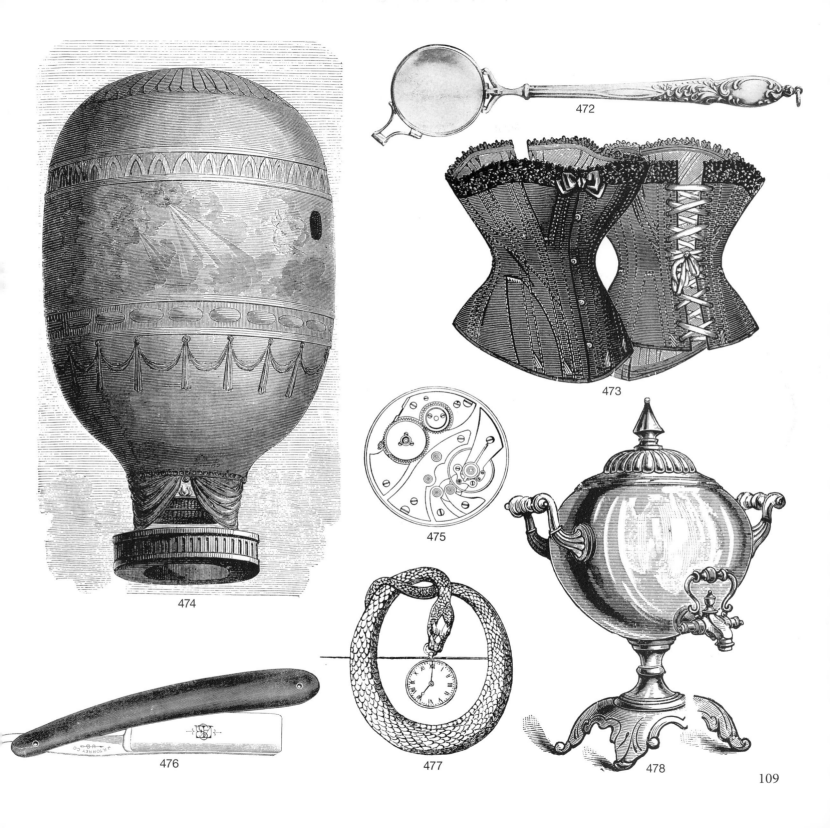

472

473

474

475

476

477

478

109

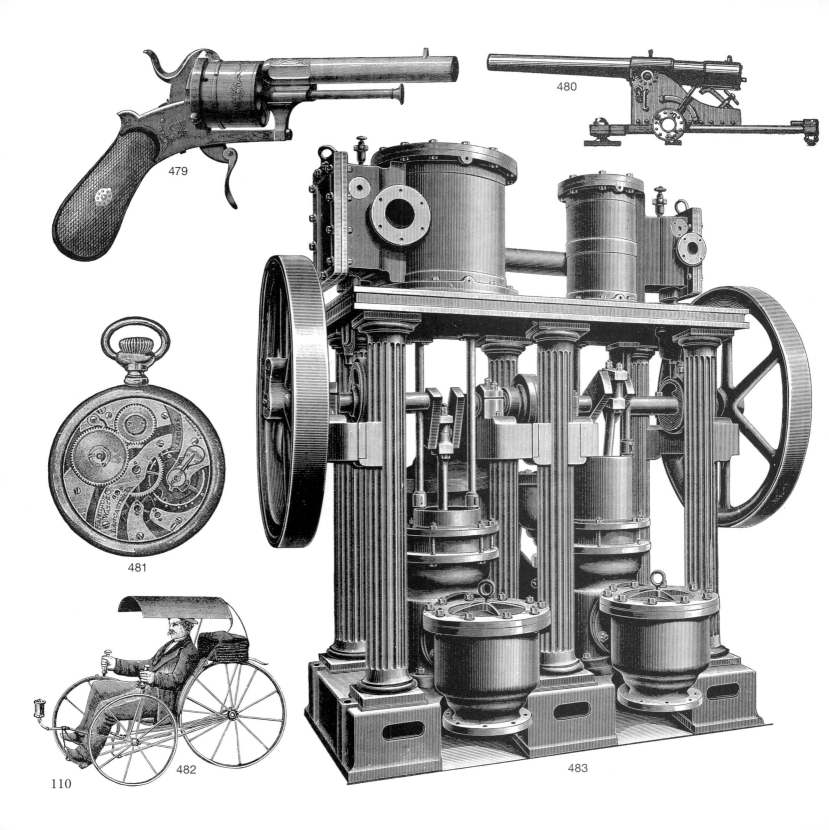

479

480

481

482

110

483

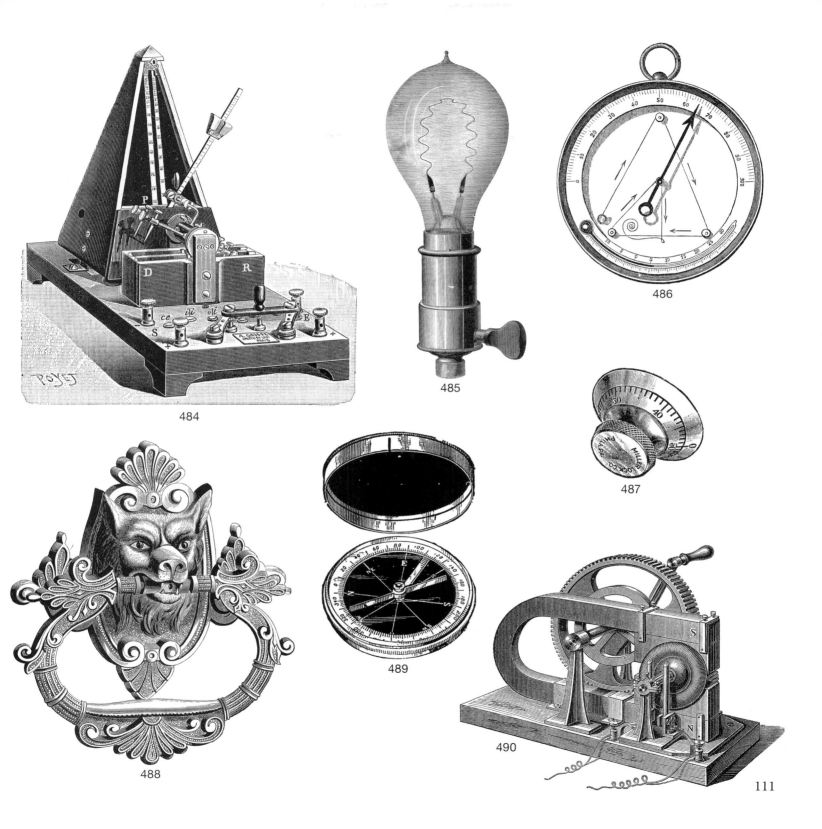

484

485

486

487

488

489

490

111

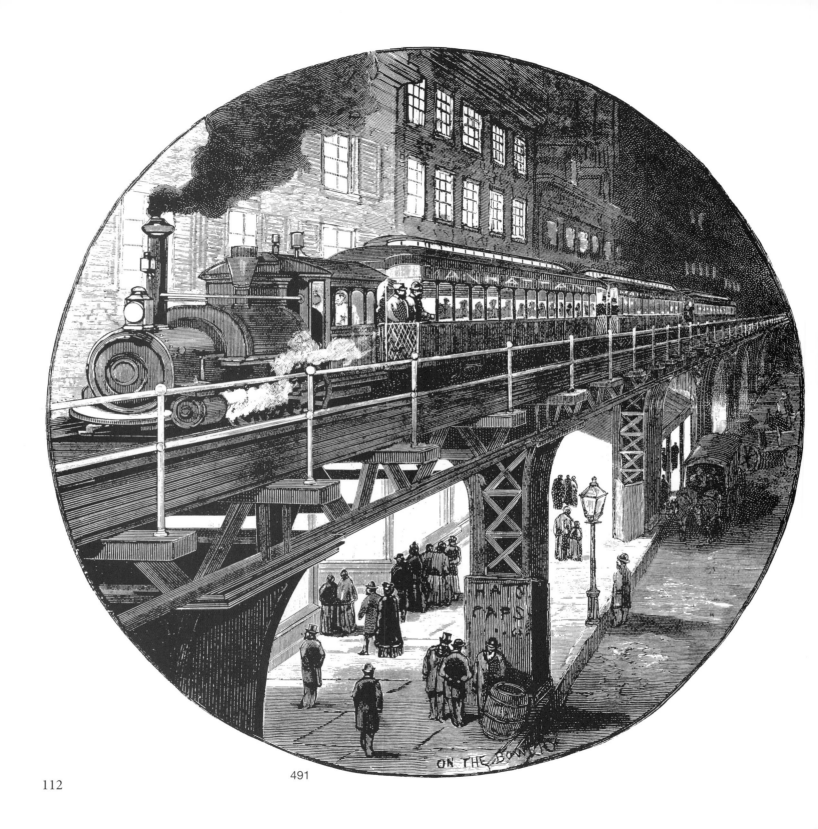

ON THE BOWERY

491

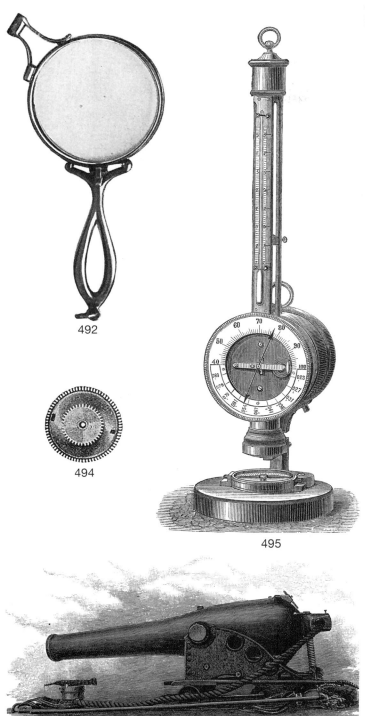

492

494

495

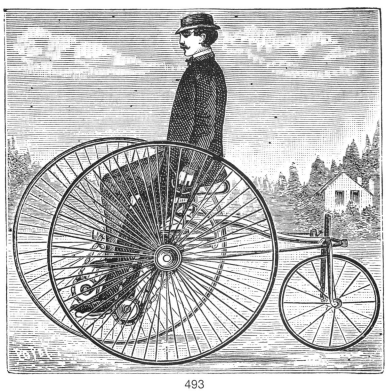

493

496

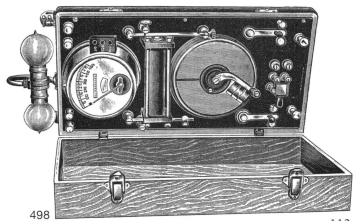

497

498

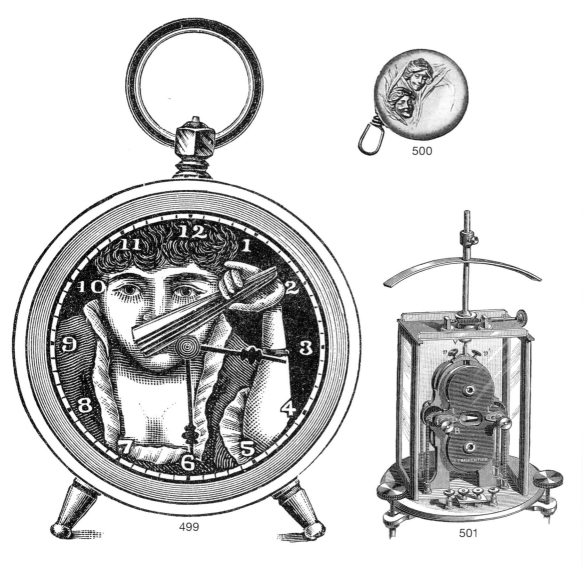

499

500

501

502

503

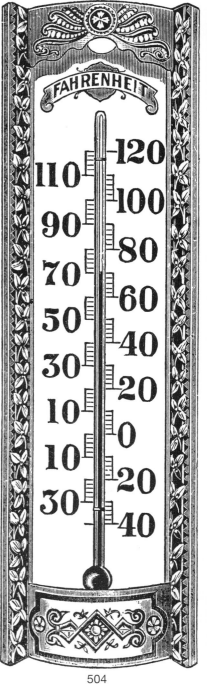

FAHRENHEIT

110
120
90
100
70
80
50
60
30
40
10
20
0
10
10
20
30
40

504

114

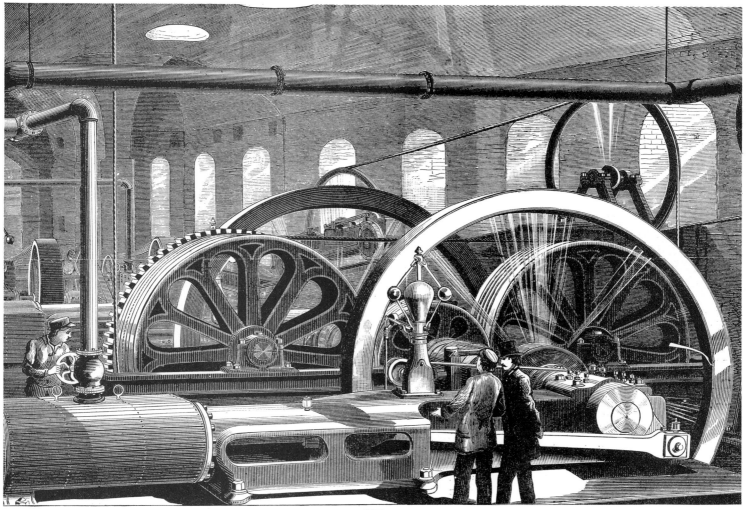

505

506

507

508

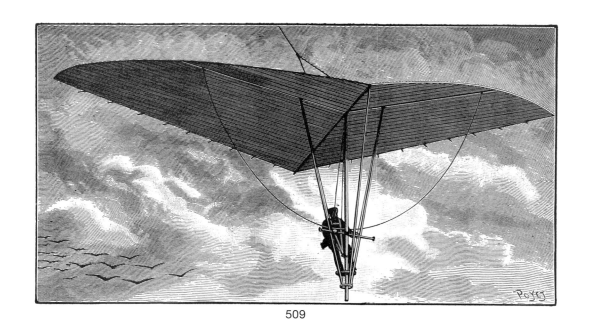

509

510

511

512

513

514

515

516

517

518

519

520

521

522

523

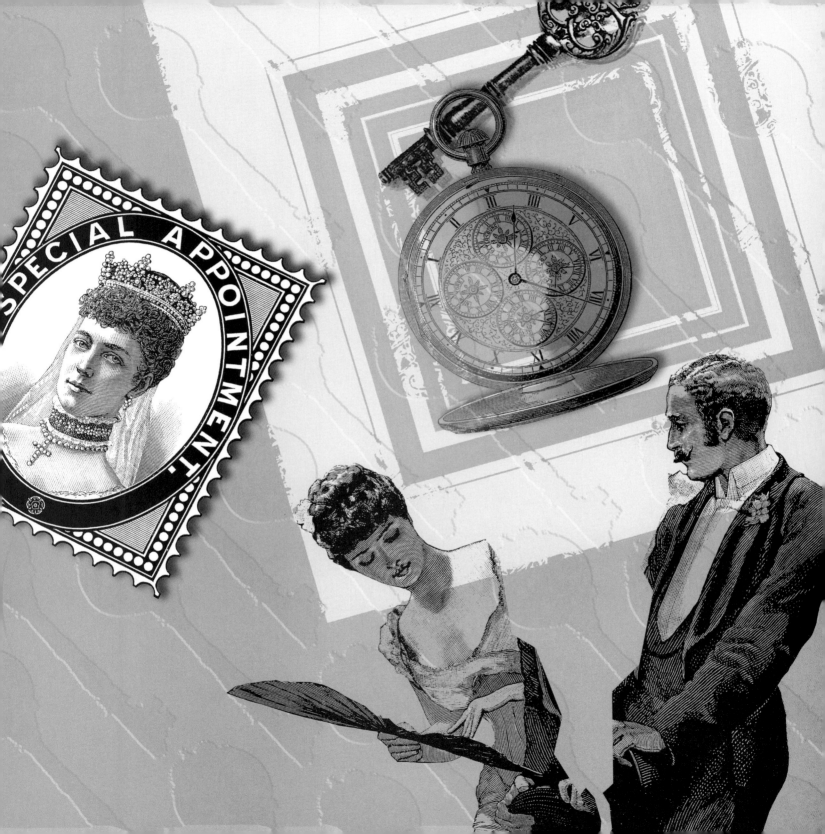

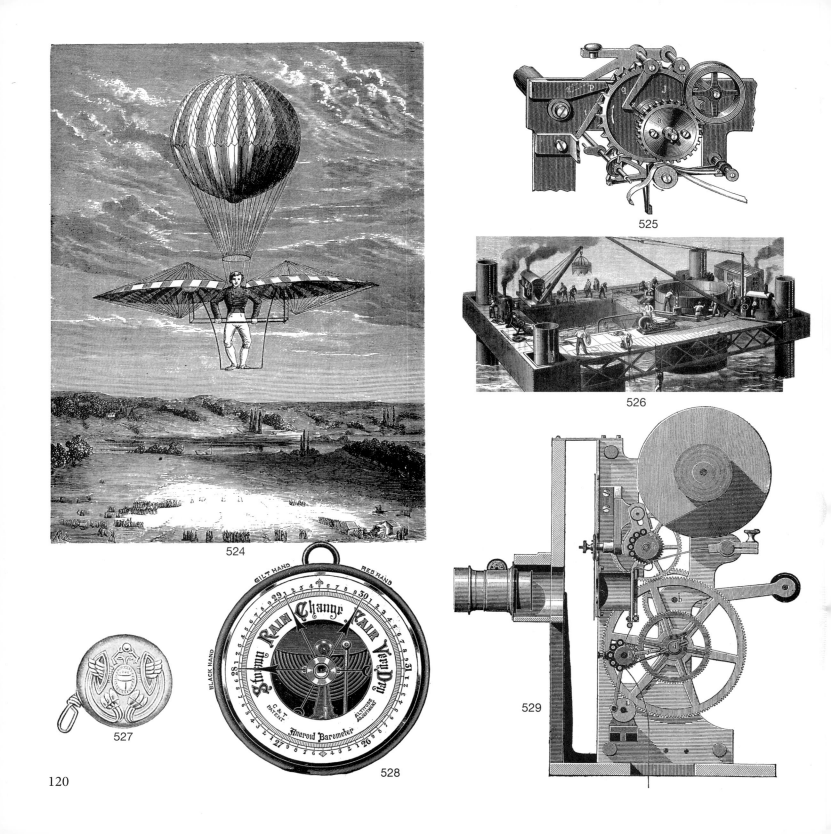

524

525

526

527

528

529

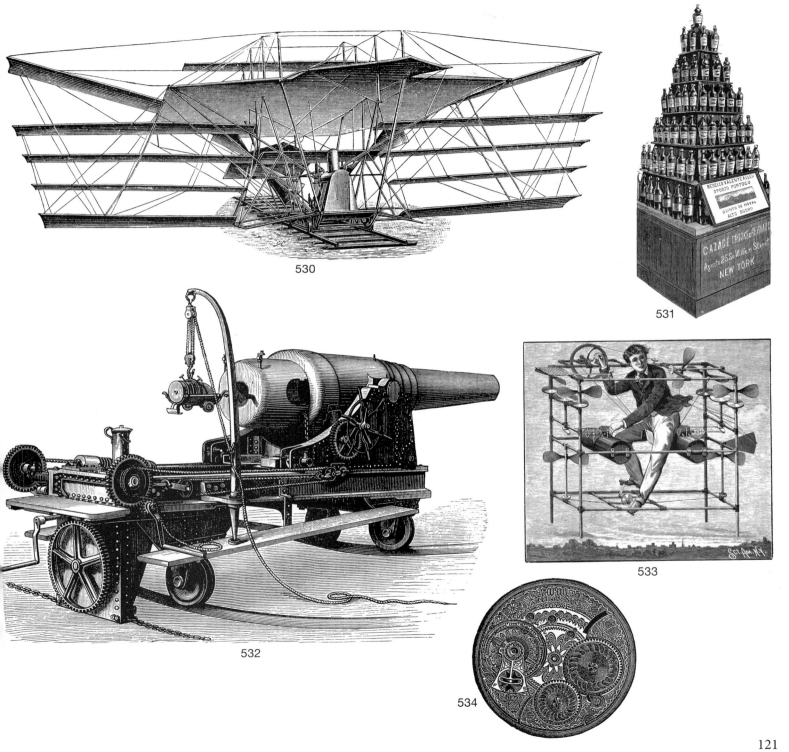

530

531

532

533

534

121

535

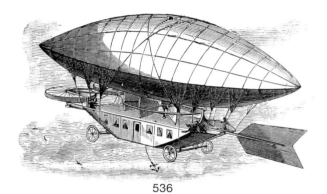

536

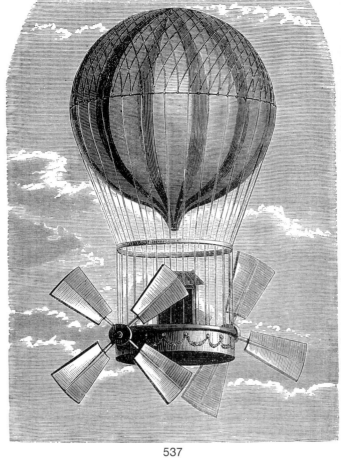

537

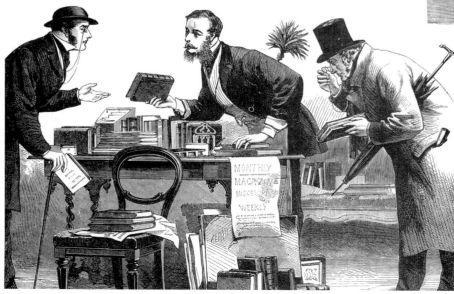

538

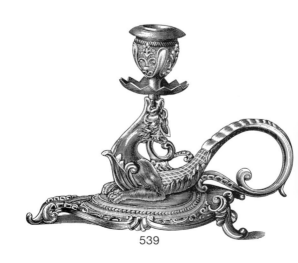

539

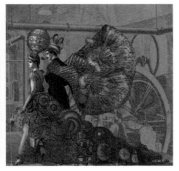

In Kyung Uhm
1st prize

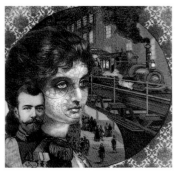

Brittany Falussy
2nd prize

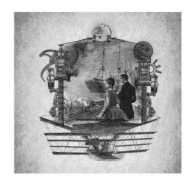

Katherine Caprio
3rd prize

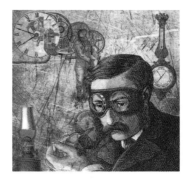

Daniela Grillo
Honorable Mention

Jing Cui
Honorable Mention

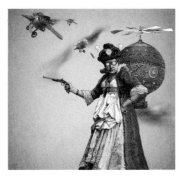

Ryan Futterman
Honorable Mention

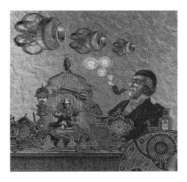

Juan Sigcha
Honorable Mention

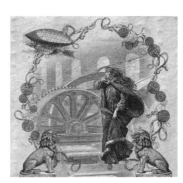

Alison K Czinkota
Honorable Mention

Adam Bohemond
Honorable Mention

Maria Karambatsakis
Honorable Mention

Yuriy Fialko
Honorable Mention

Matthew Benedetto
Honorable Mention

123

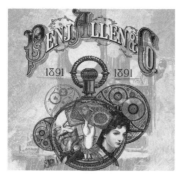
Grace Batista
Honorable Mention

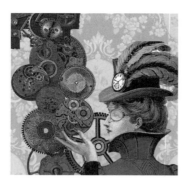
Ryan M. Blaise
Honorable Mention

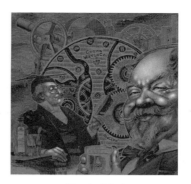
Kevin Mui
Honorable Mention

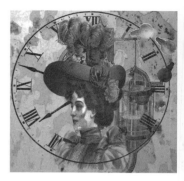
Yana Kasminskaya
Honorable Mention

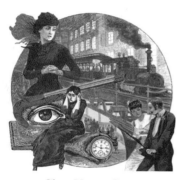
Chae Young Seo
Honorable Mention

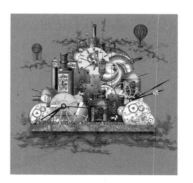
Geena Lee
Honorable Mention

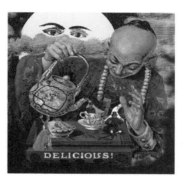
Marcella Rojas
Honorable Mention

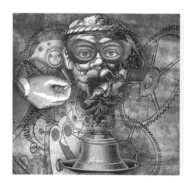
Heidi Calderon
Honorable Mention

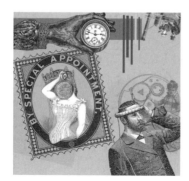
Michelle Carl
Honorable Mention

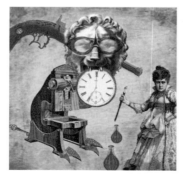
Schuyler Rideout
Honorable Mention

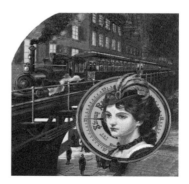
Christine Pacheco
Honorable Mention